P9-AGG-026

A
TREASURY
OF
MODERN
DRAWING

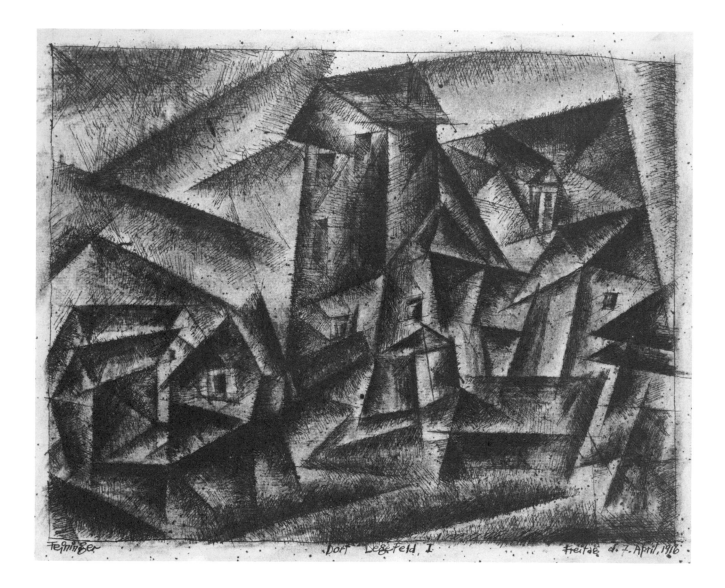

Feininger Dorf Legefeld I. Freitag d. 7. April, 1916

A
TREASURY
OF
MODERN
DRAWING

THE
JOAN AND
LESTER
AVNET
COLLECTION
IN THE
MUSEUM OF
MODERN ART

WILLIAM S. LIEBERMAN

THE MUSEUM OF MODERN ART, NEW YORK

Library of Congress Catalog
Card Number: 78-50658
ISBN: 0-87070-609-8
Designed by Steven Schoenfelder
Printed by Meriden Gravure Co.,
Meriden, Conn.
Bound by Sendor Bindery, Inc.,
New York, N.Y.
Printed in the United States
of America

cover
MATISSE: *The Necklace.*
1950. Brush and ink,
20⅞ x 16⅛"
frontispiece
FEININGER: *The Town of Legefeld.*
1916. Pen and ink, charcoal,
9½ x 12½"

INTRODUCTION

Lester Avnet was a devoted son, brother, husband, and father. His life was dedicated to his family; indeed he thought more often of them, always with pride, than he did of himself. In business, conversely, he demanded more from himself than from any associate. This drive consumed most of his energies and, eventually, his life. He found spiritual inspiration in his family, and also in his religion and in the arts, particularly classical music, contemporary sculpture, and the study of old and modern drawings.

In New York, during the 1960s, one seldom met anyone in education or in medicine, in civic affairs or in the arts, who did not already know Mr. Avnet. He was modest, completely without pretense, direct and concerned, generous and loyal. He was also a man of vision who had the ability to summon people to his enthusiasms. He asked no recognition, but many are in his debt. His presence remains and he is loved.

The Joan and Lester Avnet Collection of drawings was formed with The Museum of Modern Art specifically in mind. The collection consists of 180 sheets which range in date from 1901 through 1969. Some 40 of these were given to the Museum during the 1960s; most of the remaining drawings have been on deposit at the Museum since 1970, the year of Mr. Avnet's death.

Lester Avnet liked to remember that, in 1929 as the Museum first opened its doors, its first acquisition in any medium was a drawing, the gift of Paul J. Sachs, whom he never knew but whom in temperament he so very closely resembled. Sadly, he could not witness the inauguration of the Museum's separate Department of Drawings with its own curatorial Committee in 1971. He had, however, often urged the establishment of such a department devoted to works on paper, which share similar problems of curatorship, conservation, and display. He was troubled, moreover, that the Museum received no regular funds for the acquisition of drawings, and before his death he had intended to establish such an endowment.

On the eve of a fiftieth anniversary, Lester Avnet would have considered it particularly appropriate that The Museum of Modern Art announce the acquisition of his collection. It is catalogued here, in a preliminary fashion. It is hoped that in the near future his drawings can be permanently shared with the public, students, artists, and other collectors in the Museum's new galleries and first study room devoted exclusively to drawings.

Lester Avnet was warned by Allan Emil that the acquisition of one drawing usually leads to another. He found this true, but his thirst was also sharpened by curiosity, and he saw drawing more easily than painting. Four diverse aspects of his collection may help to define his personal taste. First, he was interested in a representation of British artists who worked during the first two decades of the twentieth century and whose drawings he considered as "a group." Second, he liked designs for theatrical productions—which, as drawings, he insisted must be as dramatic as the productions he never saw. Third, his choice of American artists was very much his own, idiosyncratic, and he wished to make it as varied as possible. Fourth, he was fascinated by sculpture, and he collected many drawings by European sculptors that are preparatory to finished works.

With the exception of Henry Moore and David Hockney, drawings by British artists have not been particularly collected in the United States. Mr. Avnet began with Walter Sickert, and his last acquisition, selected in 1969 but negotiated after his death, was a watercolor by the young Peter Blake. He also collected drawings by the Vorticists and by artists inside Bloomsbury.

The pastel by Spencer Gore, a vaudeville act illuminated by gaslight, is a study for the painting *Inez and Taki* (1910), owned by the Tate Gallery. Mr. Avnet liked to contrast it with a watercolor by Rouault (1905), a circus scene, which he had also collected. The two portraits of Vanessa Bell painting, by Roger Fry and Duncan Grant, were probably drawn in the same room as her own watercolor still life (1918). The nude by Matthew Smith (1915) Mr. Avnet compared with Modigliani. But certainly the most unexpected of any of his British drawings is John Nash's pastorale, *The Storm* (1914).

Both drawings by Walter Sickert belong to his Camden Town period. The earlier (1909), a view in Pimlico, has the intensity of a working drawing. It is a quick impression of a subject to be studied and rerendered. Balustrade, street, and then gate lead to an enclosure with silhouetted figures, and far beyond is a distant cityscape. Blocked out in charcoal and occasionally detailed in pen, the drawing offers a battery of techniques. Rougher strokes of charcoal indicate the exact rectangular area upon which Sickert wished to concentrate. Overwritings in white shimmer and also indicate color in shadow.

The second drawing by Sickert is more familiar in theme and in style. A man, Sickert's servant, poses with a model, nude, and seated on a bed. This is no romantic scene; familiarity has surrendered to ennui. The drawing is a study for a painting almost the same size. The oil offers less description of the interior and, as can a photograph, crops the man's head. The painting and two later etchings are entitled *Jack Ashore*.

More than any single sheet by any other artist associated with Diaghilev before the First World War, Léon Bakst's drawing of the Firebird summarizes the visual splendor and the dramatic impact of the Ballets Russes upon Western audiences. The design, sophisticated and virtuosic, combines the exotic and the barbaric, the Oriental and the Russian.

Igor Stravinsky, Alexandre Benois, and Michel Fokine each claimed to have been the original *inspirateur* of *The Firebird*. In fact, Diaghilev had initially approached Anatole Liadov and Mikhail Vrubel as composer and designer. The first was dilatory, the second died. Stravinsky and Alexandre Golovine inherited the commissions. Fokine, the choreographer, assembled the scenario and also danced the leading male role, the Prince. Pavlova, Diaghilev's choice for the Firebird, thought Stravinsky's score "horrible music" and flatly refused the part.[1] The title role was assumed by Tamara Karsavina. *The Firebird* marked Stravinsky's first association with Diaghilev and his Ballets Russes; it was also the composer's first success.

The premicre was held in June 1910 during Diaghilev's second Saison Russe at the Paris Opera. Two years later, when the production was revived at the Châtelet, the program made no mention of designs by Bakst, and Golovine was solely credited with the costumes and sets. Three costumes, however, had proved increasingly unsatisfactory. They probably had also been negatively criticized by Bakst, for many years Diaghilev's chief adviser. At any rate, the impresario requested completely new designs for the three costumes, the Firebird, the Prince, and the Princess, and in subsequent programs Bakst is credited as their creator. He had attended the original "think-ins" which preceded *The Firebird*, and he had in fact already conceived alternate designs not only for the three costumes requested, but also for at least two other roles. The Avnet drawing can in no way be considered a

preparatory sketch. Elaborately stylized, it is Bakst's apotheosis of the Firebird itself. The drawing was probably worked up soon after the 1912 revival, and, very possibly, after a studio photograph which posed Karsavina and Fokine in their respective roles and as they were dressed by Bakst.

Despite the taloned nails and the plumage with eyes plucked from a peacock's tail, Bakst's metamorphosis of a woman into a bird is less than complete. The costume exposes and extends, and in no way conceals, the body. He emphasizes and exaggerates its mobility, and the disjointed movements of the arms contrast with the crescent of braided hair that encircles them. The rounded forms of the impossible neck and the very full breasts also oppose the angular distortions of the shoulder and elbows.

Bakst employed assistants, and it is not always easy to identify his own hand, even in some of those drawings most frequently attributed to him. Mr. Avnet, however, was fortunate to collect another superb example. This second sheet marks Bakst's reassociation with Diaghilev after a serious disagreement.

In 1920, Diaghilev envisioned an augmented version of Marius Petipa's *The Sleeping Beauty*, which he renamed *The Sleeping Princess* in order to avoid confusion with the first production in 1890 as well as with the Christmas pantomime in London. The new production, with Tchaikovsky's music sometimes reorchestrated by Stravinsky, was scheduled to open at the Alhambra Theatre in London during the Christmas season of 1921. The ballet was conceived, by its financial backers, as competing with traditional pantomimes. Diaghilev's initial choice as designer had been Alexandre Benois, but he could not be persuaded to leave Petrograd, where he was director of the Hermitage Museum. André Derain was considered, but he also refused. Finally, Diaghilev was forced to approach Bakst, who was allowed a short six weeks to design and to mount the ambitious production, which consisted of some three hundred costumes and six sets.

Most of Bakst's drawings for the ballet were produced in Paris, where he had easy access to prints of the seventeenth and eighteenth centuries that record the sumptuous *ballet du roi* at Versailles. The Avnet drawing is characteristic of the many elaborately detailed designs Bakst created. As in many contemporary drawings for the *ballet du roi*, his splendidly clad character is

represented as a black. On the drawing itself, an erased inscription reads: "4 porters/bearers of the porfyre of the King and Queen 5th Act."

The dress rehearsal has been described by Diaghilev himself: "The stage machinery did not work; the trees in the enchanted wood did not sprout; the backdrop shifts did not come off; the tulle skirts got tangled in the flats. The premiere suffered accordingly, and the financial losses that ensued were incalculable. By staging this ballet I very nearly killed off my theatrical ventures abroad."[2] Actually, the ballet ran for more than a hundred performances, and it seems to have been well received by the public, if not unanimously by the London press. Diaghilev was heavily in debt, and Bakst was not paid. This second disagreement was final.

During his lifetime, Mr. Avnet's holdings of theatre designs were much larger than indicated by those bequeathed to the Museum. For instance, he owned additional drawings by Bakst, as well as studies for decors and costumes by Juan Gris and de Chirico. Remaining in the collection, however, are drawings by Delaunay, Larionov, and Léger, for a play and two ballets produced in Paris in the early 1920s, and two costume designs by George Grosz for Arnold Zweig's *The Case of Sergeant Grischa*, produced in Berlin in 1930.

In 1966, Mr. Avnet saw Jim Dine's startlingly fresh drawings for a new production by John Hancock of *A Midsummer Night's Dream*. The complete series had been given to the Museum by Mrs. Donald B. Straus and were shown in a special exhibition. Dine's rainbow motif dominated the visual aspect of the production. Mr. Avnet was somewhat miffed that he had not seen the drawings first, and said so. Fortunately, Dine was working in London on a second theatrical venture, a dramatization of Oscar Wilde's *The Picture of Dorian Gray*. Mr. Avnet purchased the designs the moment he saw them. Subsequently, both series were shown together in Europe under the auspices of the Museum's International Council. At the time, Virginia Allen, who directed the exhibition, wrote:

> The idea for a stage adaptation of *The Picture of Dorian Gray* evolved as a collaborative endeavor. Actor James Fox was intrigued with the idea of playing the role of Dorian. He approached Peter Eyre to play Lord Henry. Jim Dine would design sets and costumes, Michael Kidd would direct and write the adaptation, and Michael White would produce. Unfortunately, the play was canceled shortly before rehearsals were scheduled. There are interesting and obvious similarities

between the *Midsummer* and *Dorian Gray* designs. Both are annotated in Dine's "billboardese" to suggest fabrics, colors, and even construction methods. The slightly more sedate *Dorian Gray* designs indicate that "drinks, booze, tea" go in the vinyl-covered bar, while one of Lord Henry's coats is to have a "fly-front—use zipper (show it)." For all their brevity and wit, the drawings are intricately detailed down to Dorian's multiple rings. Dine uses color subjectively to establish physical juxtapositions and continuities. For instance, in costuming Dorian in blue, throughout the play, Dine achieves maximum strength from his color scheme. Basil's brown and black dress sets him apart from the decadence and debauchery of Dorian and Lord Henry, as typified in their flamboyant and colorful costumes. Peter Eyre later remembered: "There was general excitement about doing costumes that were not of Wilde's period but rather costumes that suggested the narcissistic and almost fetishist enthusiasm going on about clothes in 1967/68; and anyway it was this modern narcissism which appealed to us in the story of Dorian Gray."[3]

The Baksts and the Dines alone form a considerable addition to the Museum's holdings in works associated with the stage. At some future date, it is hoped, they will be published with all the works making up the Museum's Theatre Arts Collection.

Mr. Avnet's British drawings and his designs for the theatre can be studied. Do they, with his drawings by American painters and European sculptors, really contribute to his portrait as a collector? Perhaps not. But they do indicate his taste, his search for diversity and interrelationships.

Lester Avnet always asked questions. Sometimes the questions produced tangential results. He knew that the Museum's first major acquisitions of paintings had been the Lillie P. Bliss Collection in the early 1930s. One evening at dinner he asked, "Who advised her, and why did the factory [the Museum] change her first name?" A double-barreled question, but the answer to the first question was simple: the American painter Arthur B. Davies. A few weeks later, also at dinner before the opera, he confounded his family and a curator when he asked, "What American painter got the second one-man show at the Museum, and why?" Again, the answer to his first question was a matter of record: Maurice Sterne, in 1933. Mr. Avnet promptly sought, and acquired, drawings by both artists.

Mr. Avnet's method of collecting American drawings was in no way

systematic, perhaps because, as he repeatedly said, he could recognize no continuity in three centuries of American art. He found drawings by Preston Dickinson and Paul Cadmus, not in characteristic example, but which he liked. He also collected Whistler, Hassam and Kuhn, and Gorky, Graham, Hartley, de Kooning, Oldenburg, Rivers, Rothko, Steinberg, and Pollock, the last in a dozen examples. A few of these American drawings remain in the collection: the autobiographical Hartley; the Kuhn; two very different portraits by Graham and Rivers, the latter chosen by Mrs. Avnet; the early, pantheistic landscape by Rothko, first exhibited at Peggy Guggenheim's Art of This Century; and a Pollock purchased from his large retrospective organized by the Museum in 1967. Mr. Avnet's acquisition of his favorite drawing by an American artist was the consequence of another query: "Who's the best new picture painter in the States, and I don't mean your Motherwell?" The answer, Jasper Johns; the result, the acquisition of his *Jubilee* (1960).

Mr. Avnet's interest in sculpture was special. He controlled a method of metal-casting in which the mold is particularly faithful. Jacques Lipchitz, a friend of Mr. Avnet's, was wary of the process. He found it too accurate; it even recorded his fingerprints. Mr. Avnet also knew and admired Henry Moore and Louise Nevelson, and he collected sculpture by all three artists. The drawings by Lipchitz trace his Cubist development and also record two pieces subsequently destroyed. The single drawing by Moore that remains in the collection is perhaps the most intimate of any of the British sculptor's family scenes. Unfortunately, Mr. Avnet was too dazzled by Mrs. Nevelson as a personality. He acquired a splendid edifice of hers but never dared ask for a drawing. In the collection there are also drawings by Bourdelle, Cascella, Chillida, and Giacometti.

Mr. Avnet was fond of large sculpture, especially pieces he could place out of doors. In 1968, he and Mrs. Avnet gave to the Museum two pieces that must be roofed: Dubuffet's *Cup of Tea*, a flat inflated image six and a half feet high (1966), and Marisol's wooden representation of an American President's family, equally tall (1967). Among works by many other sculptors, Mr. Avnet owned Manzù's alternate version of his door for St. Peter's, which today can be seen in Japan in the sculpture museum at Hakone.

One-third of the Avnet Collection consists of drawings by artists of the School of Paris. They begin with a Symbolist fantasy, a collage by Kupka (1901), and include examples by Derain, Dominguez, Gonzalez, La Fresnaye, Lam, Modigliani, Rouault, and Valadon. Cubist painters as well as Lipchitz are particularly well represented. The still life by Braque (1914), also a collage, was originally owned by Stieglitz's collaborator Marius de Zayas. Its letters refer to Bach, and its lucid composition should be compared to Juan Gris's more representational still life (1916), which conversely imitates pasted papers. Gleizes, Marcoussis, Metzinger, and Picabia are shown in sheets drawn between 1910 and 1919, but unfortunately not Villon, by whom the Museum still lacks a major painting or drawing, although he is splendidly represented as a printmaker.

Artists contiguous to the Cubist movement appear frequently. For instance, Gontcharova, Kupka, Nadelman, Mondrian, and Weber can be studied from 1911 through 1914, and Itten and Brancusi in drawings of 1918. The Vorticists in England are also represented, and Bogomazov and Kliun in Russia. The single Chagall, drawn in Paris (1912), illustrates his brief but formative commitment to Cubist idiom.

Very familiar are Chagall's illustrations to the Old Testament, in painting and drawing, most eloquently in prints, and most recently in sculpture, ceramics, and stained glass. Chagall's *message biblique* is very much his own, and he incorporates within it a single but essential fact of the New Testament, Christ's death on the cross. His first painting of the visual focus of Christian worship remains his most successful. *Golgotha* was shown in Paris at the Salon d'Automne in 1912. A year later it was shown, again in a group exhibition, in Berlin at Herwarth Walden's gallery, Der Sturm. The German catalog lists its title as "Dedicated to Christ." The painting, more than six feet wide, was purchased by Bernard Koehler. The drawing, which is preparatory for the painting, was originally owned by another German collector, who in 1964 offered it to the Museum. Unfortunately, at that time, funds could not be raised for its acquisition. In 1967, luckily, Mr. Avnet saw the study in New York and immediately purchased it for the Museum.

Chagall's representation may seem unorthodox to a Christian—but, as subject, how very much more unexpected it must seem to a Jew! The scene is

easily recognizable. Chagall's interpretation, however, in no way conforms to any Christian example. His composition is asymmetric. On the bank of a river, Christ crucified is shown as a child, and Joseph and Mary stand at his feet. On the river a man paddles a boat. At the right, a ladder, here not an instrument of the Passion, is carried by a turbaned man whom Chagall has identified as evil, as Judas. As he scuttles away he glances back at the result of his betrayal.

When Alfred Barr acquired the painting in 1949, he asked Chagall to describe the composition. Chagall replied in English:

> When I painted this picture in Paris, I was freeing myself psychologically and plastically from the conception of the icon painters and from Russian art in general. . . . The bearded man is the child's father. He is my father and everybody's father. . . . The river, which is the river of my native town, flows very peacefully. . . . The figure and the boat represent the element of calmness in life as a contrast to the strangeness and the tragedy. . . . Unfortunately, this Judas *is* an invention of mine. I say "unfortunately" because I was a little afraid of his apparition. He is not in keeping with the traditional Judas. However, I gave him a ladder because I wanted to bring him down to an intimate level. . . . When I painted Christ's parents, I wanted to bring them down to more intimate dimensions, as with Judas, and I was thinking of my own parents. My mother was about half the size of my father when they got married. . . . The symbolic figure of Christ was always very near to me, and I was determined to bring it out of my young heart. I wanted to show Christ as a young child. Now I see him otherwise.[4]

"Now I see him otherwise. . . ." Chagall's later portrayals of the Crucifixion, which are many, begin in 1938. They are different but no less personal. Christ appears, quite literally, as the King of the Jews and wears, as a loincloth, their prayer shawl. In Chagall's mind, the crucified figure became a symbol of the tragedy of the Jews in Nazi Europe. In several versions, the flames of holocaust recall those pogroms that Chagall himself had witnessed in Russia many years before.

Five drawings by Picasso in the Avnet Collection span six decades. The first, selected by Mrs. Avnet, is one of several studies that relate to Picasso's large painting *Two Nudes*, acquired by the Museum in 1959.

In 1906, Picasso visited Barcelona and then spent the summer in Gosol,

in the Spanish Pyrenees. He devoted much thought to a major composition, a painting that would juxtapose two standing female nudes. His development of the theme can be traced in a series of drawings uniform in size. As he progressed, his treatment of form became less painterly, more sculptural, and the result, heroic. Both nudes derive from the same model, Picasso's companion Fernande Olivier. From other drawings we know that the hand-to-head gesture was characteristic of Fernande, and also that she had gained considerable weight since they first met in 1904. In the Avnet drawing, her features are more recognizable in the face at the left.

In the drawing, the placement of the two nudes is close to that in the final composition. In the painting, finished in Paris in the early winter, the pose of the figure at the left has changed, however; the solid bulk of both bodies is increased, and one nude stares at the spectator while the other turns away. Their stance is hieratic, and Matisse particularly admired the counterpoise of the two figures.

In the translation to canvas, Picasso's style changed. There are no soft contours. Picasso's definition of shape has been influenced by stylistic conventions of certain African woodcarvings; for instance and most obviously, Fernande's face has become a mask. Also, the proportions of the lower legs, beneath the knee, are squat. More than any other painting of 1906, the *Two Nudes* anticipates *Les Demoiselles d'Avignon*, also owned by the Museum, and finished some months later in 1907.

During the summer of every year, it became Picasso's custom to leave Paris for a change of scene. In 1909 he and Fernande traveled south to Catalonia, where they remained for four months. They first visited Barcelona. Picasso was occupied with family and friends, and he had little opportunity to work. He saw much of Manuel Pallarés, a close friend since 1895.

Pallarés, six months Picasso's senior, was born in Horta de Ebro (later, Horta de San Juan), a small village in the province of Tarragona. In 1898, when Picasso suffered some sort of malaise, he retreated to Horta to recuperate. There the two young men—they were seventeen and eighteen—lived a happy if primitive existence. Most of their time was spent camping and hiking over the rugged terrain that surrounds Horta. It was here that Picasso learned to speak Catalan. In 1900 Picasso left Spain and went to Paris.

In 1909, when Picasso returned to Barcelona with Fernande, he was delighted to see Pallarés and, in his friend's studio, painted his portrait. Like several of Picasso's transitional works, the portrait, as a painting, is unresolved and perhaps unfinished. It does, however, reveal the very direct influence of Cézanne, an indebtedness which Picasso would articulate further, and more successfully, in his very next paintings. The influence of African Negro sculpture, which had been intense, waned.

Since it was not easy for Picasso to work in Barcelona, Pallarés arranged for Picasso and Fernande to spend the rest of the summer in Horta. The town, near the Ebro River, is situated on a plain in one of the often dry areas of Catalonia. The gathering of olives and their processing into oil were the chief occupation and industry of the village. The olive mill, owned by the Pallarés family, is said to have been renowned for the purity of its product. The factory and the Pallarés home were located in the upper part of the town and afforded a view of the river.

Gertrude Stein, who owned earlier and later preparatory drawings for the *Two Nudes*, gave the following account of the visit:

> Once again Picasso in 1909 was in Spain and he brought back with him some landscapes which were, certainly were, the beginning of cubism. These three landscapes were extraordinarily realistic and all the same the beginning of cubism. Picasso had by chance taken some photographs of the village that he had painted and it always amused me when every one protested against the fantasy of the pictures to make them look at the photographs which made them see that the pictures were almost exactly like the photographs. Oscar Wilde used to say that nature did nothing but copy art and really there is some truth in this and certainly the Spanish villages were as cubistic as these paintings. . . . Then commenced the long period which Max Jacob has called the Heroic Age of Cubism, and it was an heroic age.[5]

In Horta, Picasso actually painted four landscapes, not three, and several heads of Fernande. The first landscape is a view of the mountain Santa Barbara, which for Picasso was not unlike Cézanne's Mont Sainte-Victoire in its configuration and in its challenge. Picasso gave the picture to the Pallarés family, and it was subsequently acquired by Ambroise Vollard. The other three landscapes, all representing the buildings of the village, were purchased, and later described, by Gertrude Stein.

In all four landscapes Picasso geometrizes the analysis of Cézanne. But the catalyst which refined Picasso's method into Cubism was also, and as much, the very landscape, architecture, and colors of Horta, as Gertrude Stein emphasizes. Both influences, Cézanne and Horta, are distilled in a fifth landscape, a watercolor and the second drawing by Picasso in the Avnet Collection. The result of Picasso's sojourn was pivotal in his evolution as an artist. During a summer, scarcely a vacation, Cubism was born. Independently, but at the same time, Braque reached similar conclusions, also in landscape.

Upon returning to Paris in the autumn, Picasso rendered the Avnet watercolor into a larger oil on canvas. *The Mill at Horta* shows the Pallarés family's compound, almost a fortification. Among the buildings it is difficult to distinguish which are the dwellings and which is the mill. The architecture of the compound is said to have included also a kiln and a tower or stack. Picasso focuses not upon the identity of the buildings, but upon their visual effect as structures, as rectangular and spatially related blocks. The palm tree is said to have been the artist's invention. The river, only suggested in the drawing, is developed in the painting, which is now in a private collection in Paris. The Avnet drawing has been exhibited once before, in Berlin in 1927.

In her discussion of Picasso and Cubism, Gertrude Stein mentions his friend, the poet Max Jacob. Another French poet, and a somewhat lesser friend, stressed the special significance of Picasso's summer and the subsequent months. In 1928 Breton wrote: "In the future, there will be passionate investigation into what may have animated Picasso toward the end of the year 1909. Where was he? How was he living? Can that silly word Cubism disguise the prodigious sense of discovery which, to me, exists between *The Factory at Horta de Ebro* and the *Portrait of Kahnweiler?*"[6]

One of Picasso's happiest liaisons was with Marie-Thérèse Walter during the 1930s. When it was over, he continued to visit her briefly but regularly and could say, "You were the best of wives." In 1945, he spent a few of the first days of the new year with her and their daughter Marie-Conception (later, Maia). Fuel was a constant problem in wartime France, and in January 1945 it was cold. Picasso drew three versions of logs burning in a fireplace. The first, the Avnet sheet, was drawn on January 4 in pen and ink and then

colored with red crayon. Animated tongues of flame leap like twisting acrobats; the image is memorable, indeed unique in Picasso's art. The drawing should be situated within the development of the Museum's large painting *The Charnel House*, which Picasso began before the Avnet sheet and which was realized, if not completed, some months later.

The two remaining drawings by Picasso in the Avnet Collection date from the 1960s. For very many years, except when rendering portraits and even not always then, Picasso no longer had need to draw or paint from the model to portray the human figure. Late at night, when he held no court and when his household was asleep, Picasso produced hundreds of drawings and prints, usually in black and white, until he could fall asleep. The subject matter of these works on paper is overwhelmingly narrative and, sheet by sheet, sometimes episodic.

It is impossible not to speculate about one scene that presents Picasso's fantasy at its most bizarre. The sheet is crowded with figures of different sizes. The players seem stolen from disparate contexts, and they are cast in a drama that remains a private allegory Picasso could never have put into words. Picasso himself refused to explain these characters and was offended when he was asked. As if personally affronted, he swept a photograph of the drawing to the floor.

In 1966 Picasso was eighty-five. During his last years, the loss of sexual prowess, but not appetite, greatly influenced and sometimes enraged his attitude toward the essential relationship between man and woman, at least in his art. Picasso had consistently portrayed the male, often an artist, as a dominant and superior being. This is certainly not true of the Avnet drawing, however, which for lack of a better title is called, descriptively, *Figures*.

The composition of the drawing divides itself in halves. At the left a large man appears, nude, bearded, and with unkempt hair. His pose is awkward. He tries to balance on his toes, his knees are bent, his torso is flabby. His hands behind him, the figure seems cramped within the rectangular confines of the sheet. Is he some humbled hero? To the right moves a bare-chested woman, her face in chiaroscuro, her hair upswept. From her left hand she dangles a straggly knotted string above two runts who crawl on the floor and who seem to be in dialogue. Is the woman some sorceress, a Circe who has

reduced them to their shrunken size? Was that, perhaps, the fate of the two small humanoids which, in the background, are enmeshed in a web of lines? Who will be her next victim? Behind the woman is the face of a second man. His shoulder repeats the gesture of her outstretched arm, but his gaze is vacant. Why is he unshaven? Is he the artist himself?

At the extreme right stands a third man swiftly delineated in wash. He seems to witness the scene, and he resembles the musketeers who people many of Picasso's paintings and drawings of the same time. At the extreme left, Picasso has annotated the three days during the week in which he labored on the drawing. On March 12, he interrupted his work and drew a separate scene of musketeers; and on the day he finished the Avnet sheet, March 15, he began a second drawing of several figures that are similarly and elaborately reworked in pen and ink and wash.

How very much happier is Picasso's next and last drawing in the Avnet Collection! The commemoration of the centennial of Ingres's death came in 1967. Picasso's own contribution was light-handed. On four successive days in late January, he drew in pencil a dozen scenes inspired by Ingres's *The Turkish Bath*. The painting, of course, is in the Louvre, but Picasso's variations seem to have been drawn from memory, and fondly. The Avnet sheet is the largest in the series.

Throughout his career Picasso paid respects to artists of the past, from Cranach to Renoir, sometimes in homage but most often in parody. Here the element of caricature, which occasionally is so disturbing in Picasso's work, is delightfully expressed. In Picasso's version of Ingres's seraglio pool, form is unmodeled and described exclusively by line. The drawing was a favorite of Mr. Avnet's.

In the Avnet Collection, German artists are represented by a score of drawings. The earliest are four portraits drawn before the First World War. Corinth painted for many years in an academic style, with profitable success. The likeness of his wife, however, is unexpectedly fresh. In 1903 they had just been married, and, on a walking tour through Bavaria, the artist's very young wife fell ill. Corinth draws her unaware, propped up in bed, and asleep. The subject, repeated in an oil sketch, is one of Corinth's most tender.

It in no way suggests, as does a later drawing in the collection, the subsequent and tumultuous redirection of his art.

Kirchner's couple shows the artist with one of two orphaned girls, Franzi or Marcella, who lived with the Brücke artists before they moved to Berlin in 1911. The scene suggests, rather innocently, the Bohemian life style of the brotherhood when they were young and were still together. Kirchner's fluid line contrasts with his later abrupt and angular draftsmanship. The sketch is rapid and unsigned.

Klee's early portrait is much more carefully studied. *Hannah* is one of two or three likenesses of a painter and friend in Bern that he drew in 1910 and etched in 1912. During his first years as an artist, Klee worked almost exclusively as a printmaker and draftsman. His very few portraits done directly from life belong to this period. The bust is monumental, its frontal symmetry relieved only by the bow that exposes an ear. Klee's interest is clearly in tonal values, and *Hannah* seems much more painterly than other drawings and illustrations of the same time. Also, it should be remembered that the Brücke, the first German Expressionists, had been painting in Dresden since 1905 and that Klee certainly had seen their work.

Meidner's portrait might be called "the artist and the metropolis." The year is 1912, the city is Berlin, and Expressionism, at least with Meidner's brush, has gone berserk. The artist, a victim, claws through the frame of the drawing as he tries to escape from the desolate chaos of the factories and houses behind him. With the bursting glare of an exploding bomb, the moon unrelentingly illuminates his flight. "I was painting day and night my own afflicting oppression and fear of the Last Judgment, of an end of this world."[7]

Ludwig Meidner is one of the least-known of the German Expressionists. He seems to have led an existence of unmitigated woe. For a few years his vision was inspired and authentic, but he was never able to repeat it. The Avnet drawing belongs within a series of similar cityscapes, all equally prophetic and apocalyptic in their nightmare, which Meidner painted and drew between 1910 and 1913. In 1907, a younger and perhaps happier man, he had visited Paris, where he met Modigliani. Together they visited the great Cézanne exhibition of that year.

In 1919, Feininger, an American, was probably the first artist asked by

Walter Gropius to join the faculty of the Bauhaus School in Weimar. He designed a woodcut for its opening manifesto and remained at the Bauhaus first as a Master and later as an artist-in-residence until the school closed in 1932. Among other artists who joined the faculty, two are represented in the Avnet Collection by pre-Bauhaus drawings. Kandinsky's *Horseman* of 1916 brings the fluency of his earlier abstractions to narrative vignette. It is one of fourteen watercolors drawn during a stay of four months in Stockholm. It is also a Russian fairy tale, complete with a plumed prince.

In relation to his past and future oeuvre, these watercolors seem retrograde in style. Kandinsky himself described the series as a "Biedermeier" mixture. The second drawing by a future Bauhaus master is by Johannes Itten, a Swiss. The fragmentation of his female and certainly Germanic Asmodeus owes as much to Expressionism as it does to Cubism and black-humored Dada. Later drawings, by Feininger and Klee, specifically belong to the Bauhaus years in Weimar, as does Schlemmer's scheme for *The Figural Cabinet*.

From elsewhere in Germany, two later portraits are completely Expressionist in style. Kokoschka's young model in Dresden is Gitta Wallerstein, the daughter of an art dealer who was a friend of the artist as well as a collector of his work. While a teacher at the Dresden Academy, from 1919 to 1924, Kokoschka painted several portraits of children, including one of Gitta. The mottled impasto of the paintings seems frequently overworked. Much more spontaneous are the watercolors. In the Avnet drawing, it is clear that the artist has complete cognizance of the sitter's physiognomy. The sheet is stroked with wet brushes holding colors so varied and so brilliant that a comparison with Nolde is surely invited.

A second portrait by Corinth is this time his own. More than twenty-five years the senior of Kokoschka, Corinth was born in the generation of Seurat and Ensor. When he was fifty-five, just before the First World War, his style underwent a rapid change for which there seems to be neither biographical nor spiritual reason. His brushwork and draftsmanship became more free, even virtuosic, his attitude conversely more introspective and profound. The liberation of his later style was undoubtedly influenced by the example of the younger Expressionist painters.

Like so many German artists, Corinth was obsessed by his own image, which he repeated over and over again in paintings, drawings, and prints. The Avnet self-portrait, perhaps intended as a lithograph, was drawn shortly before he died. Haggard and worn, the artist stares into his studio mirror, which in turn reflects two other views.

With the exception of a sheet by Beckmann drawn soon after the end of the Second World War, the last drawing by a German artist in the Avnet Collection is a quasi-idyllic scene by Hofer. It seems, today, very old-fashioned, and not only because of the dress and cap of the sleeping bather. The distortions of the human figure have no meaning; Expressionism has become mannerism.

In the twentieth century, the mechanization and industrialization of our age have been glorified, condemned, and mocked. Several drawings in the Avnet Collection serve as illustrations. They begin not with the Futurists in Italy, but with the Vorticists in England. A brief comparison between two sheets by David Bomberg shows an artist's swift transition to a style that seeks relation to mechanical form and movement. Bomberg drew both figure compositions within a year and while he was still a student in London at the Slade.

Jacob Epstein's studies for his sculpture *Rock Drill* (1913) develop, more specifically, a mechanical theme. The drawing in the Avnet Collection is essential since it describes Epstein's original conception, realized but subsequently destroyed: the life-size figure of a laborer operating a drill. Epstein's first version celebrated not only the power of the machine, but also the dynamism of a man.

During the previous year, in 1912, Epstein had installed a major commission, Oscar Wilde's tomb, in the Père Lachaise Cemetery. While in Paris he met Modigliani, who was then a sculptor, and Brancusi, who warned him that "one must not imitate Africans."[8] In Paris he also saw Cubist painting. Ezra Pound remarked that Epstein, back in London, "was the first person who came talking about form, not the form of anything."[9]

Upon his return, Epstein worked intensely and in isolation. During a few concentrated months he carved stones that, in retrospect, are seminal to the history of modern sculpture but have slight affinity to Cubism as it developed

in Paris. Epstein's early period culminates in the late fall and winter of 1913, when he sculpted and then constructed his *Rock Drill*.

The torso of *Rock Drill* was modeled and carved in plaster. "I made and mounted a machine-like robot, visored, menacing, and carrying within itself its progeny, protectively ensconced."[10] Epstein then bought "an actual drill, second hand, and upon this I made and mounted a machine-like robot," the plaster torso. When the assemblage was exhibited in London in 1915, Epstein even "thought of attaching pneumatic power to my rock drill, and setting it in motion, thus completing every potentiality of form and movement in one single work." A Futurist vision!

At the time of the exhibition, Wyndham Lewis wrote: "The nerve-like figure perched on the machinery, with its straining to one purpose, is a vivid illustration of the greatest function of life."[11] Several months later, however, Epstein changed his conception. "I lost interest in machinery." He discarded the ready-made drill, severed the arm which held it, and amputated the driller's legs. The hero of the machine age became its victim. A bronze cast from the truncated plaster is in the Museum's collection, as are two additional preparatory drawings. One study shows the drill in furious motion; the other, *Birth*, describes a symbol of procreation, the embryo settled within the driller's rib cage.

Epstein's drawings and his *Rock Drill* anticipate by a very few months Vorticist theory, which erupted in publication in the summer of 1914. Percy Wyndham Lewis and Ezra Pound joined as the polemicists for the movement, declaring Cubism stale and Futurism picturesque. Vorticism, in fact, derived from both. Through exhibition, the impact of Futurism had been particularly strong, more than that of Cubism. In London even the most knowledgeable confused Vorticism with Futurism. For instance, in December 1913, Edward Marsh wrote to Rupert Brooke: "Another new light whom I met today is Wyndham Lewis. I am going to the Picture Ball, if you please, as a futurist picture designed by him!"[12]

In the first issue of the magazine *Blast*, Wyndham Lewis declared: "The Modern World is due almost entirely to Anglo-Saxon genius—its appearance and its spirit. Machinery, trains, steam-ships, all that distinguishes externally our time, came far more from here than anywhere else. . . . Machinery is the

greatest Earth medium: incidentally it sweeps away the doctrines of a narrow and pedantic Realism at one stroke."[13] Against such certainty, it seems superfluous to observe that Bomberg and Epstein were Jews and that Gaudier-Brzeska was French. At any rate, the Vorticists in England, like Léger in France, believed that new, challenging, and as yet unexplored subject matter existed outside the studio and in the paraphernalia of the industrial age. Such theories were soon implemented by the real machines of war by which Vorticism died.

Epstein remarked that "Lewis's drawing has the quality of sculpture."[14] This is certainly true of the two standing figures in the small Avnet study (1912). Gaudier-Brzeska's larger sheet (1913) was obviously drawn from the model. Neither specifically relates to the machine age. Nevertheless, like the seated nudes by Léger (1913) and Lipchitz (1915) in Paris, they could only have been conceived in it. A more exemplary illustration of Vorticism is Lawrence Atkinson's untitled composition of 1914. It fits, almost tailor-made, Richard Cork's recent summation:

> The Vorticist ideal was an independent synthesis of Futurism and Cubism, the romantic and the classical, and its desire for control wars with its dynamism so fiercely that a wholly distinctive tension results. The typically diagonal forms of a Vorticist picture thrust outwards, as if the artist is straining to burst the bounds of the picture-frame; but they are contained, even so, by an insistence on precise contours and a solidity of construction which is often sculptural in its implications. Time and again the Vorticist appears to fragment . . . picture-surface to the point of total dispersal, and then recant by locking all its forms together into an inevitable, thoroughly immovable structure.[15]

Not even Bloomsbury could close its ears to the Vorticist blast. Vanessa Bell's brief experiment (1914) is astonishing in design as well as in date.

Unlike the Cubists in Paris, the Vorticist painters and sculptors were for a short time cohesive as a group and together listened to T.E. Hulme, the philosopher, and the original owner of Epstein's drawing *Birth*, when he urged a "new geometric and monumental art making use of mechanical forms."[16] But Hulme and Gaudier-Brzeska were killed in the First World War, which totally dispersed the group. Upon his return from the front in 1919, Christopher Nevinson, another Vorticist painter and printmaker, wrote to Edward Marsh, now Minister of Munitions: "It needed a little moral cour-

age to come out of what I consider a cul-de-sac of pure abstract painting and the mere consideration of pure plastic form for its own sake, though I admit I have learned more from this cul-de-sac than from any other school. But, quite simply, at the front I suddenly felt a desire to express something more than a picture."[17]

Lyonel Feininger was fascinated by steamships, trains, and cities. As an adult, he also remembered vividly that moment when as a child he had first comprehended the engineering feat of the Second Avenue Elevated. In the summer of 1906 he took his wife Julia on a promised trip to Paris. They remained in France, on and off, for two years. He continued as an illustrator and as a cartoonist, and in 1907 began to paint in oil.

Feininger sketched the narrow streets, high houses, and busy pedestrians of Paris. He also explored the capital's environs, which were then still suburbs. As always he was fascinated by architecture. One day he found a towering monument, the Aqueduct of Arceuil, which remained throughout his life one of the three chief architectural motifs of his art. The structure consists of two engineering triumphs: the first, a seventeenth-century aqueduct; the second, a viaduct added on top of it in the nineteenth century. One of Feininger's first paintings in oil was the tall two-storied stone bridge.

In 1911 Feininger returned to Paris, this time alone. Julia, meanwhile, had abandoned her own career in art; she too had been a proficient draftsman. On this visit Feininger saw Cubist painting, and the way he looked at the city changed. "The cross-hatchings of Paris: the tall thick chimneys that grow out of the flat chimneys, with many small ones like flowerpots—the utterly silent old gas candelabra—the horizontal lines of the shutters—in the suburbs the crosshatched smudges on the walls next to the shutters—the thin cornices on the roofs which we saw in the Rue de Rivoli—the crosshatched glass roof of the Grand Palais des Arts—the store windows divided by lines—the railings of the balconies—the grid of the Eiffel Tower—the greater linear effect of the lateral and central laths of the balcony doors in comparison with our windows—the chairs out-of-doors and the little café tables with spidery legs—the gilt-topped fences enclosing the parks."[18] Kafka speaks for Feininger.

Feininger spent the First World War in Germany. Throughout his career

he continued certain specific themes, and in the Avnet Collection two studies of the aqueduct were drawn a few days apart in March 1915. As was his custom, the first was in black and white, the second a watercolor. These in turn were followed by a painting.

In Germany, Feininger's style completely absorbed the planar analyses and the lateral rhythms of Cubism. In 1916 and 1917 he was particularly concerned with movement and, quite literally, set buildings in motion. *Legefeld*, the most tumultuous of these paintings of churches and towns, has been lost. The Avnet Collection, fortunately, owns its preparatory study. Unlike much of Feininger's work, the drawing carries no aura of the bittersweet or nostalgic.

The horizontal rectangle of the composition is drawn freehand, in contrast to the outlines of buildings, street, and sky, which the artist established by striking the paper with the inked edge of a ruler. Scrubbed shadings in charcoal and hundreds of scratched lines give form. The complete sheet is covered with flicks from a pen. These tiny random touches further animate the vibrations of the architecture.

In January 1913, Francis Picabia with Gabrielle Buffet, the second of his three wives, arrived in New York as the first ambassador of the Parisian avant-garde. He was thirty-four years old. The Picabias were, one would like to imagine, the first foreign visitors to the Armory Show. It opened a few weeks after their arrival, and it was the reason for their visit. As an exhibitor, Picabia excited as much notoriety as did his friend Marcel Duchamp, who was absent but whose painting *Nude Descending a Staircase* proved an all-time popular winner.

Picabia and Gabrielle were an attractive couple. In New York they furnished three ingredients so often necessary to artistic and social milieus: curiosity, taste, and style. Gabrielle wrote an article on the new art, as did Picabia anonymously (and in French), for a "special" issue of Alfred Stieglitz's magazine *Camera Work.* They were also effective as propagandists in conversation and in interview. But it was Picabia's own lucid thinking, his urbanity and punning wit, as well as his physical presence, that delighted the press and hostesses such as Mabel Dodge. His firmest relationship remained his friend-

ship with Stieglitz, and it developed into an intellectual exchange that the photographer permitted to few other people. Picabia contributed as much to Stieglitz's understanding of the modern movement as did Marius de Zayas, also in New York, and Edward Steichen in France. He also became a good friend of Walter and Louise Arensberg, whose prime allegiance, however, would be reserved for a second ambassador from France, Marcel Duchamp.

In New York Picabia considered himself a Cubist, and he was headlined as such by the press. *The Procession, Seville,* and *Dances at the Spring* were admired and derided during the run of the Armory Show. Both are four feet square and both are in American collections. Two other canvases, also painted in Paris in 1912 but twice as large, more clearly indicated how Picabia's style and use of color would change during his few months in New York. These paintings are *The Spring* and *Dances at the Spring,* the latter a composition completely different from the version in the Armory Show. Both paintings, like so many of Picabia's works, were mislaid; they have been recently uncovered, or rather unrolled, by Grace Mayer and are now in the collection of the Museum.

In March 1913, two days after the Armory Show closed, Stieglitz presented New York studies by Picabia in the side room of the gallery at 291 Fifth Avenue. The small exhibition consisted of sixteen watercolors painted on American-made surfaced illustrator boards which Picabia had purchased at Friedrichs on West Fifty-seventh Street. Picabia, at the time, considered the series as preparatory to a major painting in oil—*"un plus vaste tableau."*[19] The watercolors were originally uniform in size, twenty-two by thirty inches, and Gabrielle remembered them stuck to the walls of their apartment at the Hotel Brevoort, where they were discussed and displayed before the exhibition at 291. The Avnet drawing, *New York,* is one in the series. It is not colored, and Picabia perhaps considered it particularly. At any rate, it was the one he chose to send to Berlin, where it was shown at the gallery Der Sturm in Herwarth Walden's large roundup of the European avant-garde. The study was acquired in 1924 by the German painter Friedrich Vordemberge-Gildewart, an artist associated with Lissitzky and the Stijl group, who also owned the drawing by van Doesburg in the Avnet Collection.

"The machine has become more than a mere adjunct of life. It is really

part of human life," Picabia wrote, "perhaps its very soul."[20] And, for Picabia, New York was the metropolis of the machine age. The Avnet watercolor reflects and echoes the sights and sounds of the city, at least as they appeared to Picabia. It may also allude to certain divertissements of New York life, for instance Negro dancing and music. If this is true, Picabia did not make such allusions specific. In his synthesis, flat crescent shapes simultaneously overlap circular and rectangular forms. From this mosaic emerges, in perspective, the diagonal thrust at the top of the sheet. The movement is rotating and disjointed. The metallic shades of gray and black, in watercolor and sometimes very wet, have slightly faded. The passages of white gouache are corrective to Picabia's original design, and their intensity has increased. Upon close inspection, areas originally orange, as in another *New York* drawing at the Art Institute of Chicago, are seen to have been overpainted. The Avnet sheet is closest to a study colored with blues and browns at the Metropolitan Museum of Art.

According to Gabrielle, Picabia worked furiously upon their return to Paris. His interest in rhythms of movement became less generalized, and he concentrated on the painted and drawn invention of single how-to-do-it contraptions. Two later watercolors of 1919, in the collection, spoof the machine and tick merrily away to Dada time.

In Berlin, in 1921, there is nothing joyful about the watercolor of another Dadaist, Hannah Höch. The image is strange, almost alarming, and the machine *is* man. A human mask is screwed onto a support, which in turn is attached to an armature only partially seen. The machine, some sort of press, is about to be activated by its own hand, the arm of which is a coiled cord. Although small in size, the composition is monumental, and it is said to be a study for a larger painting unfortunately unlocated.

"Half shooting gallery—half *metaphysicum abstractum.* . . . Variety of sense and nonsense, methodized by Color, Form, Nature, and Art; Man and Machine, Acoustics and Mechanics, Organization is everything; the most heterogeneous is the hardest to organize."[21] Thus begins Oskar Schlemmer's account of the staging of his mechanical cabaret, *The Figural Cabinet.* The piece, a farce of modern times, was first produced at the Bauhaus School in Weimar, where Schlemmer had joined Feininger as a Master. It was per-

formed again a year later in 1923 during a "Bauhaus Week" in Jena that was the first major Bauhaus exhibition.

The Figural Cabinet lasted fifteen minutes. Mechanical figures and objects acted out a scenario of directed chaos. The movements, noises, and colors built up to a frenzy and ended only when the Master, the modern organization man, shot himself. Several characters and incidents mentioned in Schlemmer's account appear in the Avnet drawing: "The great green face, all nose," whose rainbow eye lights up; Meta, whose "head and body disappear alternately"; the "Giant Hand says: Stop!—the varnished angel ascends and twitters tru-lu-lu"; and "at each side abstract linear figures with brass knobs and nickel bodies, their moods indicated by barometers." At the right, as can be seen in the drawing, was placed a crank with instructions to "please grab me!"

Hans Bellmer was born in Poland. In Berlin during the 1930s, he constructed a series of life-size dolls of an adolescent girl. Growing out of his fantasy of the young girl as a pubescent machine, his constructions were placed in various poses and photographed; he also drew them obsessively. In 1938, after the death of his first wife, he moved to Paris. He married his young niece, who had been the object of many of his fantasies, and dressed her as a little girl. The Avnet nude relates to the Museum's painted aluminum cast of the doll itself.

Drawn in the same year as Bellmer's doll, and by coincidence also in white on black, Léger's plan to camouflage the Eiffel Tower is serious. The drawing is one of three projects, each different in its nighttime disguise. In Paris, from Seurat to Delaunay, the mechanical marvel had been the symbol of the first machine age. In 1937, Léger was obliged to dress the Tower for a Second World War.

With one exception, Dubuffet's succession of thirty drawings were published by the Museum in 1968. In black and white, they trace his development year by year from the mid-1940s, when he resumed painting, through 1961. Among the earliest are a representation of an actual place and a likeness of an actual person. The landscape is a small pen-and-ink study of a grove of pine trees near Cassis. The portrait is that of Michel Tapié, the French author and artist, a relative of Toulouse-Lautrec and the defender abroad of the Gutai

group in Osaka. The last drawings by Dubuffet are two large collages. Each represents three figures whose bodies are dendritically integrated into the texture that surrounds them. All thirty drawings were originally in the private collection of the French art dealer and connoisseur Daniel Cordier.

Dubuffet composes in series, methodically, sometimes obsessively. The following sequences are represented in the Avnet Collection: "Marionettes of the City and Country" (1944); "Portraits, More Beautiful Than They Think" (1946); "Grotesque Landscapes" and "Metro and Metromania" (1949); "Corps de Dames" (1950); "Landscape Tables" (1951); "Radiant Lands" (1952); "Cows, Grass, Foliage" (1954); "Carts, Gardens" (1955); "Texturologies" (1958); and "Legends" (1961). Three sheets were drawn in New York City in the winter of 1951–52. *Goat with a Bird* (1954), which has not been previously reproduced or exhibited, belongs to one of three series of "Imprints" in which Dubuffet experimented with various methods of ink transfer, including decalcomania.

The Avnet Collection also contains drawings by other European artists working since the Second World War. Picasso, as has been seen, is represented, and also Balthus, by a portrait of a young girl, Laurence Bataille. Four sculptors, Cascella, Chillida, Giacometti, and Gonzalez, can be studied as draftsmen. Alechinsky, Appel, and Lucebert represent the Cobra group, and their fevered, animalistic fantasies might be compared with the eerie allegories of Juliusz Studnicki in Poland. Mr. Avnet was also one of the first to collect López-García and Szafran, today two of the most interesting draftsmen in Europe. Among his postwar drawings, Mr. Avnet particularly admired three which he hung in his office: Beckmann's *The Letter*, Matisse's *The Necklace*, and Delvaux's *The Astronomers*. Each, very differently, celebrates the female nude.

In 1937, Max Beckmann refugeed himself in Amsterdam, where during the next decade he painted five monumental triptychs. The largest and most ambitious of these is the brilliantly colored *Blindman's Buff*. The Avnet study, drawn while Beckmann was completing the triptych, is like chamber music to the complex orchestration of the painting. In black and white, the drawing isolates and develops one of the two reclining figures in the central panel. It also reverses the pose of a nude which had been the subject of an earlier

painting of the same year. The model fills the width of the sheet. Beckmann first described the contours of the shapes by line. Then with loose strokes of a pen he filled the areas of flesh, which contrast with the unshaded letter, chemise, and couch. The vase, with its flowers, was probably the first area drawn and sits between the artist and his model.

The single Matisse in the Avnet Collection is splendid. Drawn in 1950 when he was eighty, it displays an authority of draftsmanship that seems to say no earlier drawing could be more Fauve. As an artist, Matisse had complete knowledge of every aspect of the female form—indeed, so much so that he often treated it as still life. In the Avnet drawing, in less than thirty broad, assured strokes, Matisse quickly defines the head, arms, and torso of a standing model. With some half-dozen more jabs of a brush, he creates her necklace; and how vividly animated is the passage that describes the two hands fingering the beads! Matisse made one stroke too many, and, not without amusement, Mr. Avnet liked to point out that the artist had whited out the model's navel.

The notebooks of Delvaux number many small volumes. From the sketches they contain, Delvaux establishes two types of larger drawings: first, drawings in black and white, elaborately finished, that are preliminary statements of compositions he will subsequently enlarge and modify in oil on canvas; second, pen-and-ink drawings, less dense in detail, which he enhances with washes of color. The colored drawings Delvaux considers independent works, final statements, and they do not serve as preparatory studies.

The Astronomers is a perfect example of his first type. The composition was indicated in pencil, and then Delvaux detailed the drawing in pen and black ink. Two months later he completed the painting, about five times as large. In both drawing and painting, exactitude of description and sharpness of perspective lend reality to an otherwise unlikely scene.

At the left, several men have gathered for some sort of discussion. They are the same age, all wear glasses, none looks particularly happy. They confer under an open cast-iron shed. The architecture of the structure, like the style of their dress, belongs to the late nineteenth century. Engaged with themselves, the men are completely oblivious to the naked woman standing a few feet away. Her exact position, in the drawing, is somewhat ambiguous. She

poses between flowerless plants in the foreground and a grove of trees beyond. Unnoticed, she contributes an element of insouciance. Certainly, she would not dally with any of the balding elders. Delvaux, at any rate, allows her no encounter. Behind these principal players and beginning with an iron fence, a succession of horizontal and parallel vistas recedes toward a distant horizon on which are settled locomotives and other indications of an industrial age. At the far right, a Sapphic couple stroll through the grove. Beyond them, steps mount to a large house. A man and, again naked, a second frolicking couple can be seen on the stairs.

The abrupt juxtaposition of the clad and naked is commonplace in Delvaux's art. But who exactly *are* these strange, slender men? Delvaux, very specifically, identifies them as astronomers. Two of them derive from Jules Verne, whose science fiction was Delvaux's favorite reading when he was a child. The man standing in front of the table is Otto Lidenblock, a German professor of "philosophy, chemistry, geology, mineralogy, and many other ologies," who appears in Verne's *Voyage to the Center of the Earth*.

Delvaux has borrowed the figure, quite literally, from a late nineteenth-century illustration for the novel, which, he says, "has seduced me ever since I was ten years old. I was interested in the fabulous voyage to the center of the earth and in a slightly comic, very picturesque side of the professor's personality. I even copied the illustration and pinned it to the wall of my study."[22] Since 1938, Delvaux has incorporated the professor into a number of paintings and drawings. In the Avnet sheet (1961), but not in the subsequent painting, the professor is seen with his back turned. The second savant, standing at the left, is Verne's Palmirin Rosette.

This sheet by Delvaux was among Mr. Avnet's last acquisitions. In less than a decade he had assembled a collection of drawing in our time. His achievement was extraordinary, and it is in part recorded here.

Mr. Avnet was particularly fond of comparisons, for instance, a drawing by Valadon in Paris in 1910 and one by Schiele in Vienna in 1911; or Tchelitchew's contrasting portraits of two literary tigers, Gertrude Stein and Edith Sitwell. He was also fascinated by sheets that are doubly faced, and from Bonnard to Rothko collected such examples.

The Joan and Lester Avnet Collection of twentieth-century drawings totals 180 sheets. It is the largest gift of drawings ever received by the Museum. Many of the images it contains relate to other works already in the Museum's collection. That frequently was the reason they were chosen.

The reproductions which follow describe about half of the collection. They have been chosen to represent its diversity, and their sequence is strictly chronological. A preliminary checklist of the collection, compiled by Monawee A. Richards, begins on page 108.

In the preparation of this catalog of the Joan and Lester Avnet Collection, Mrs. Avnet has been an invaluable collaborator as well as a friend. Both she and the Museum owe very much to the guidance of Lillian L. Poses, who has been both shepherd and cicerone.

As he would have wished, this catalog is dedicated to every member of Lester Avnet's family.

NOTES

1. *Stravinsky and the Dance* (New York: The Dance Collection of the New York Public Library, 1962), p. 38.

2. Charles Spencer, *The World of Serge Diaghilev* (London: Paul Elk, 1974), p. 102.

3. *Jim Dine: Ein Sommernachtstraum, Das Bildnis des Dorian Gray* (Berlin: Amerika Haus, 1970), unpaged.

4. Letter dated October 11, 1949, to Alfred H. Barr, Jr., The Museum of Modern Art.

5. *Gertrude Stein on Picasso*, ed. Edward Burns (New York: Liveright, 1970), p. 14.

6. André Breton, *Le Surréalisme et la peinture* (Paris: Gallimard, 1928), p. 16.

7. Thomas Grochowiak, *Ludwig Meidner* (Recklinghausen: Aurel Bongers, 1966), p. 65.

8. Cited in *Epstein: An Autobiography* (New York: Dutton, 1955), p. 49.

9. Richard Cork, *Jacob Epstein: The Rock Drill Period* (London: Anthony d'Offay, 1973), p. 3.

10. This and the following comments by Epstein on his *Rock Drill* are cited in Cork, op. cit., p. 56.

11. *Wyndham Lewis on Art*, ed. Walter Michel and C. J. Fox (New York: Funk and Wagnalls, 1977), p. 86.

12. Christopher Hassall, *Edward Marsh* (London: Longmans, Green, 1959), p. 258.

13. *Wyndham Lewis on Art*, p. 30.

14. Cork, op. cit., p. 7.

15. Richard Cork, *Vorticism* (New York: Davis and Long, 1977), p. 9.

16. Cited in Cork, *Jacob Epstein*, p. 9.

17. Hassall, op. cit., p. 459.

18. Kafka cited in *Georges Braque: His Graphic Work*, Intro. by Werner Hofmann (New York: Abrams, 1961), p. v.

19. *Francis Picabia* (Paris: Galeries Nationales du Grand Palais, 1976), p. 67.

20. William A. Camfield, *Francis Picabia* (New York: The Solomon R. Guggenheim Foundation, 1970), p. 23.

21. *The Theater of the Bauhaus*, ed. Walter Gropius, trans. A. S. Wensinger (Middletown, Conn.: Wesleyan University Press, 1961), p. 40.

22. "Lettre de Paul Delvaux," published in *Cahier de l'Herne* (Paris), no. 25 (1974), p. 108.

ILLUSTRATIONS

KUPKA: *View from a*
Carriage Window. 1901.
Gouache and watercolor,
19⅞ x 23⅝″

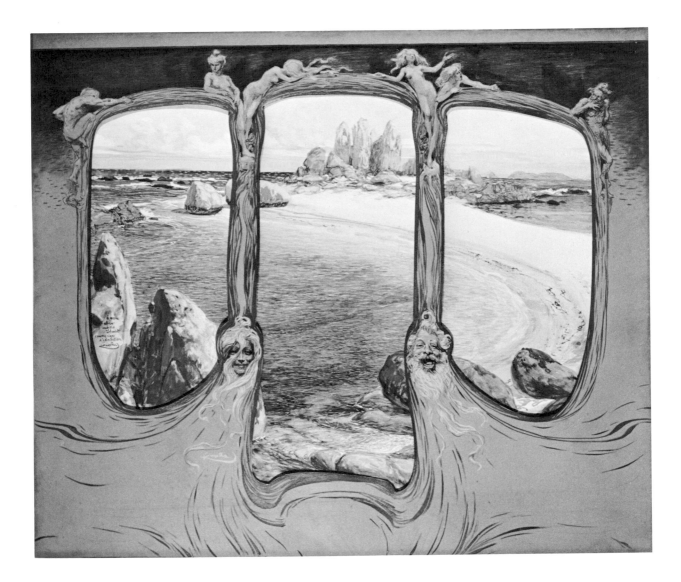

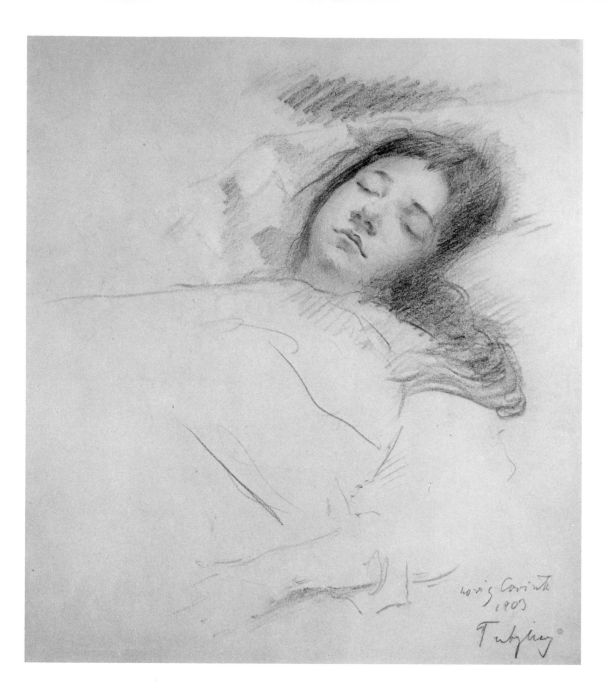

Lovis Corinth
1903

opposite
CORINTH: *The Artist's Wife
Asleep.* 1903. Pencil,
13⅞ x 13½"

DELVILLE: *Expectation.*
1903. Pencil and charcoal,
39¾ x 17½"

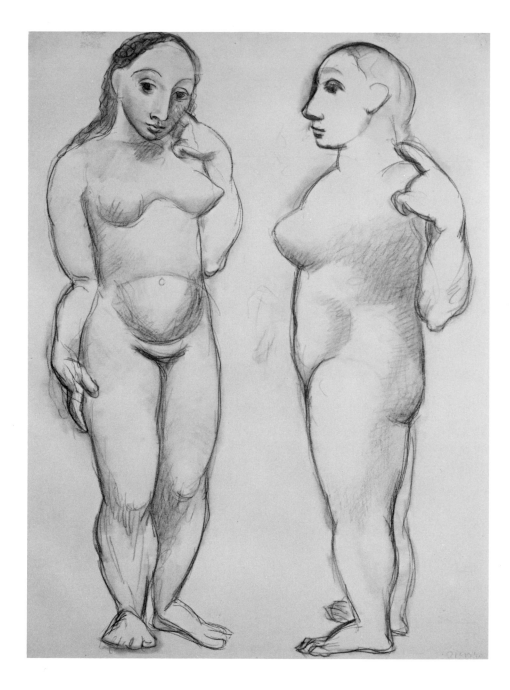

Picasso: *Two Nudes.*
1906. Charcoal, 24⅜ x 18½"

opposite
Picasso: *The Mill at Horta.*
1909. Watercolor, 9¾ x 15"

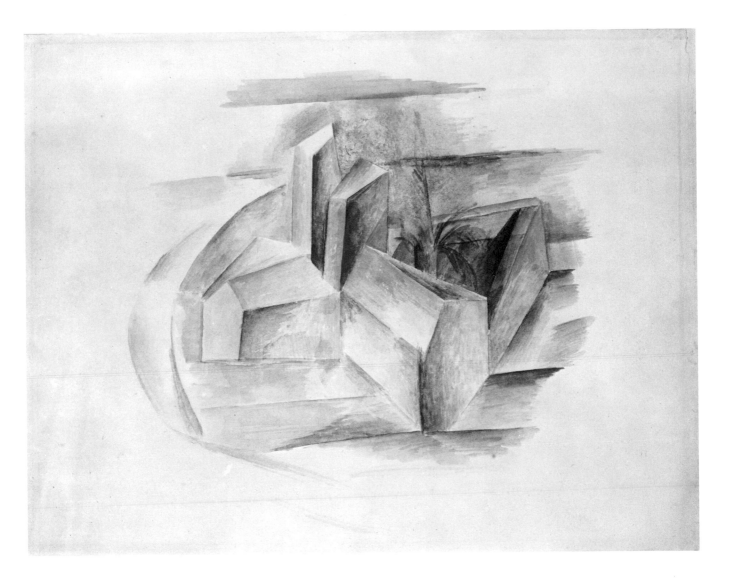

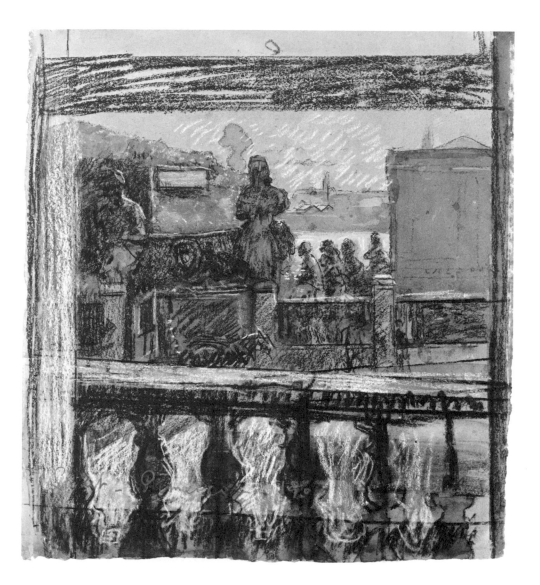

SICKERT: *Pimlico*.
1909. Charcoal, pastel, wash,
pen and ink, 21¼ x 19⅜"

opposite
KIRCHNER: *A Couple*.
1909. Pencil, 13⅝ x 17"

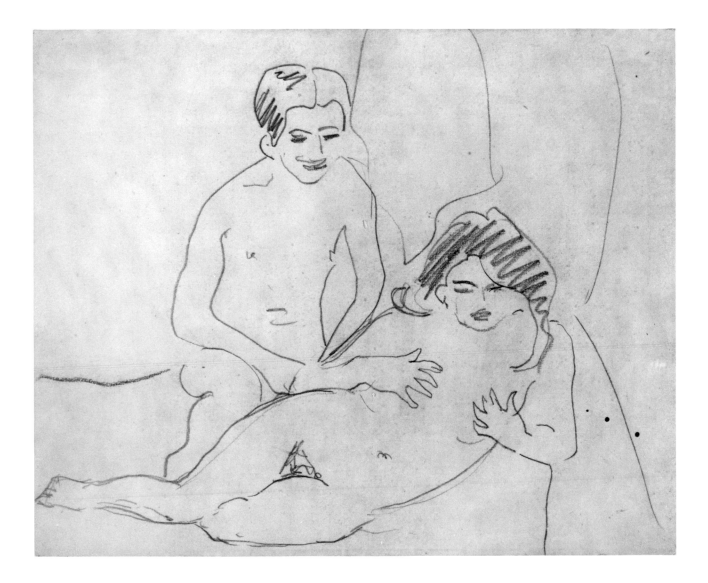

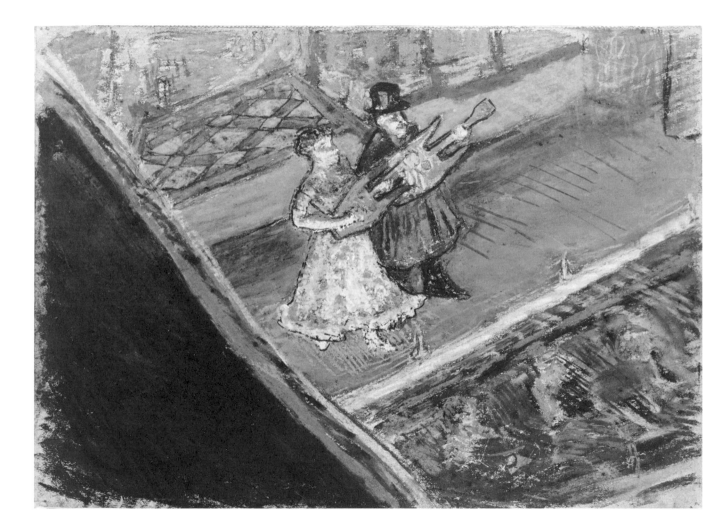

opposite
GORE: *Inez and Taki.*
1910. Pastel and pencil,
8⅛ x 11⅛″

VALADON: *The Children's Bath.*
1910. Crayon, 12⅞ x 14½″

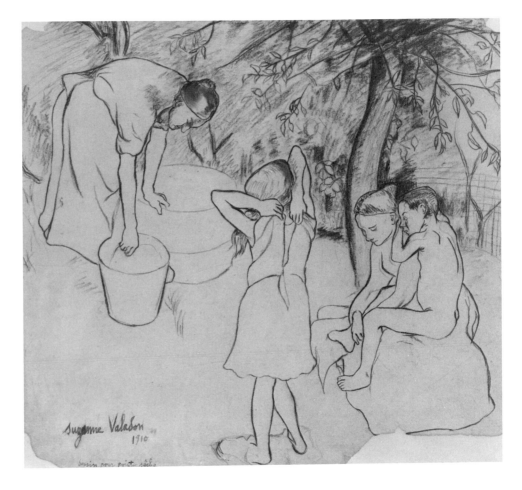

45

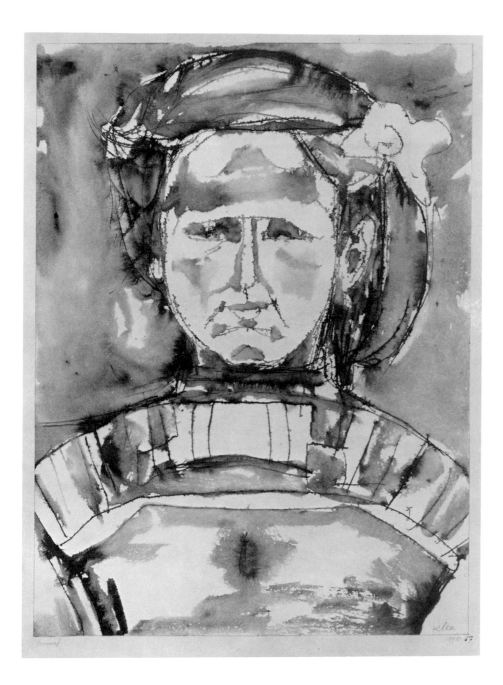

KLEE: *Hannah.*
1910. Wash, pen and ink,
10⅝ x 7⅞"

SCHIELE: *Woman Wrapped in a Blanket*. 1911. Watercolor and pencil, 17⅝ x 12¼"

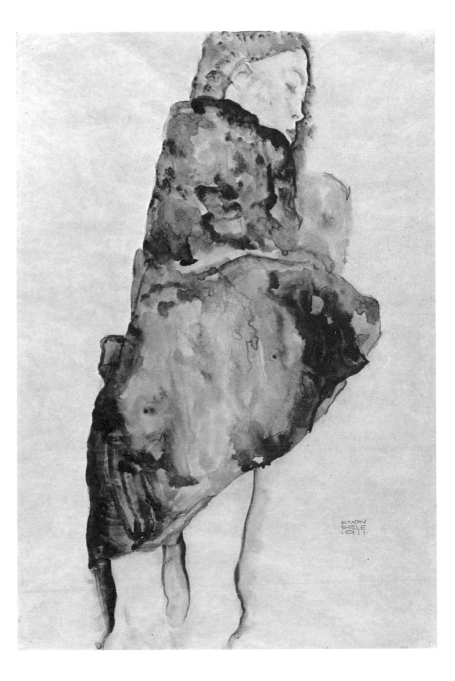

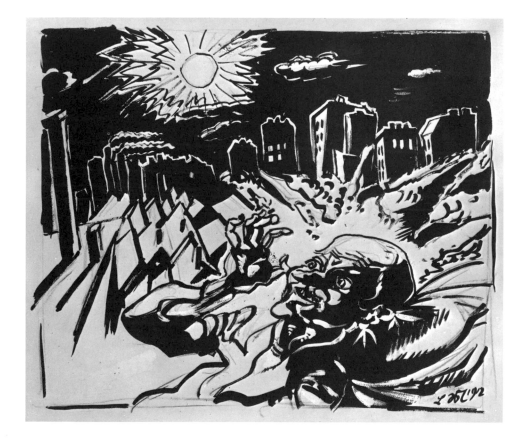

MEIDNER: *O Moon Above So Clear!* 1912. Brush and ink, tempera and charcoal, 15¾ x 19¼"

opposite
CHAGALL: *Golgotha.* 1912. Gouache, watercolor, and pencil, 18⅝ x 23⅜"

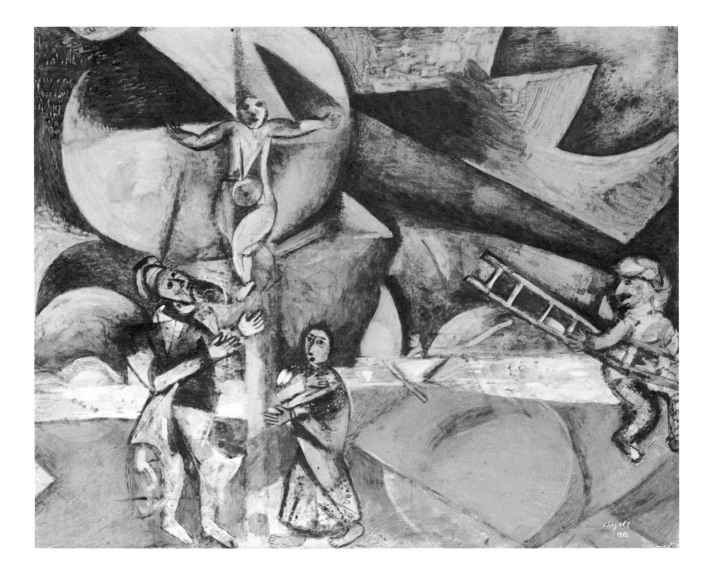

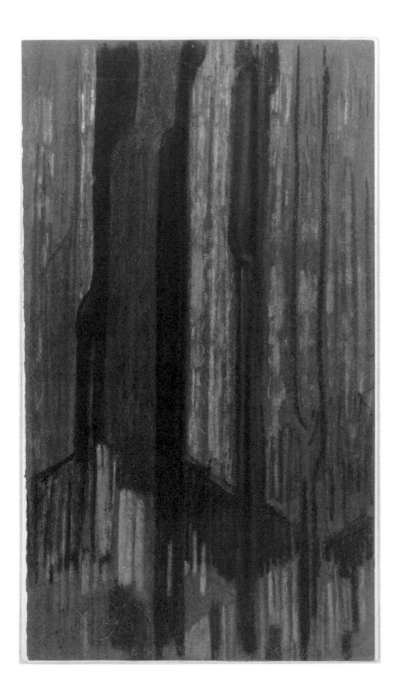

KUPKA: *Study in Verticals.*
1912. Pastel, 16 x 8⅞″

MONDRIAN: *Church Facade.*
1912–14. Charcoal, 39 x 25"

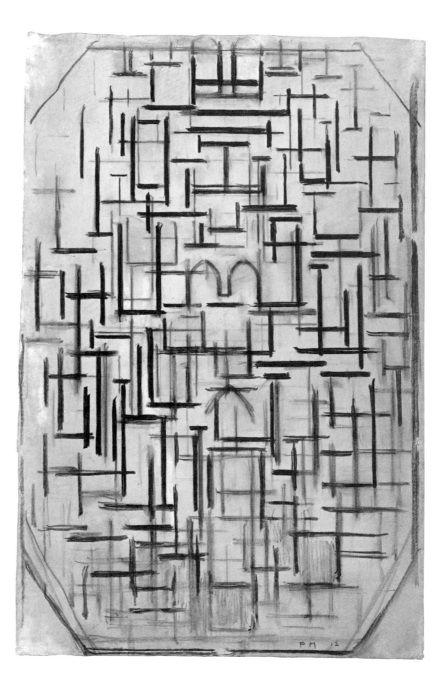

52

opposite
BOMBERG: *The Return of Ulysses.* 1913. Charcoal, 12⅛ x 18½"

BOMBERG: *Family Bereavement.* 1913. Charcoal, 21⅞ x 18⅜"

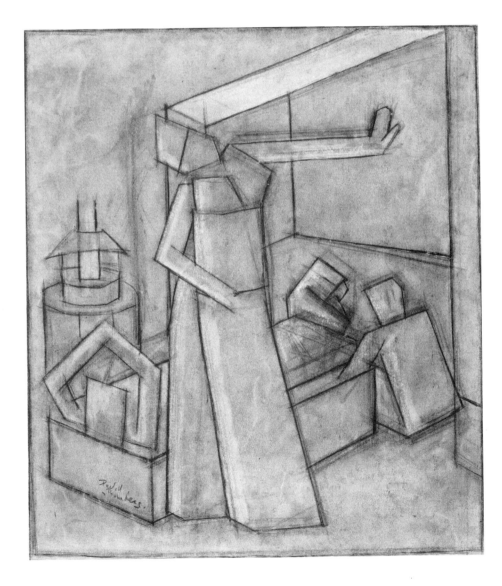

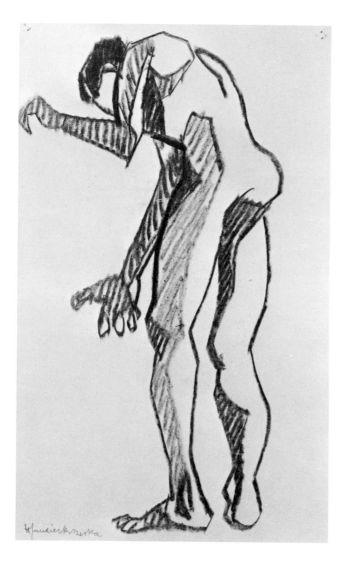

far left
GAUDIER-BRZESKA: *Standing Nude.* 1913. Chalk, 15 x 10⅛"

left
EPSTEIN: *Rock Driller.* 1913. Chalk, 27⅜ x 17⅛"

BAKST: *The Firebird.* 1913. Watercolor, pencil, and metallic paint, 26⅞ x 19⅜"

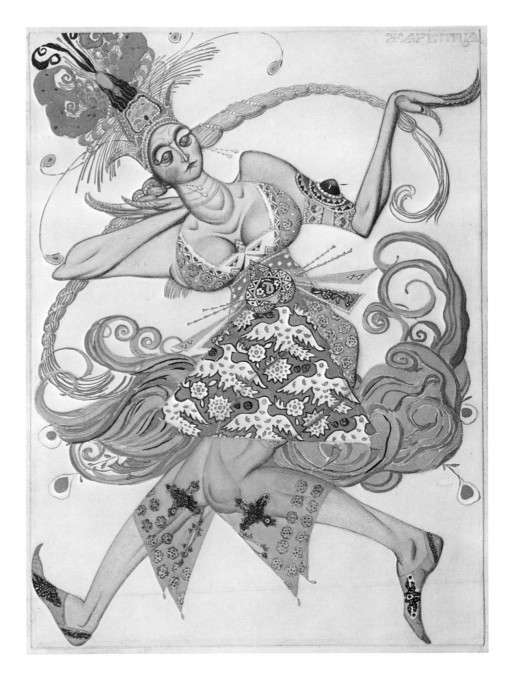

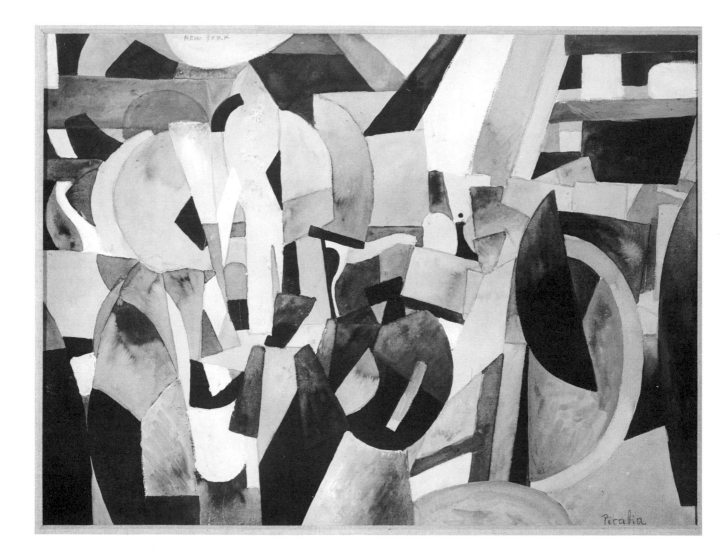

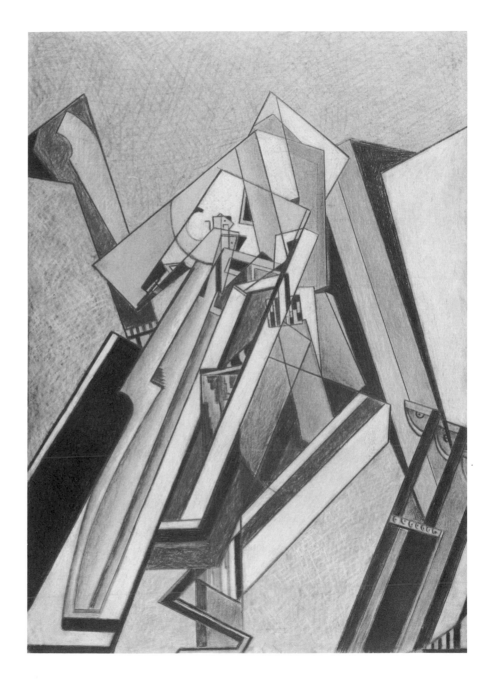

opposite
PICABIA: *New York.*
1913. Gouache, watercolor, and
pencil, 22 x 29⅞"

ATKINSON: *Composition.*
c. 1914. Pencil and pastel,
31¾ x 21¾"

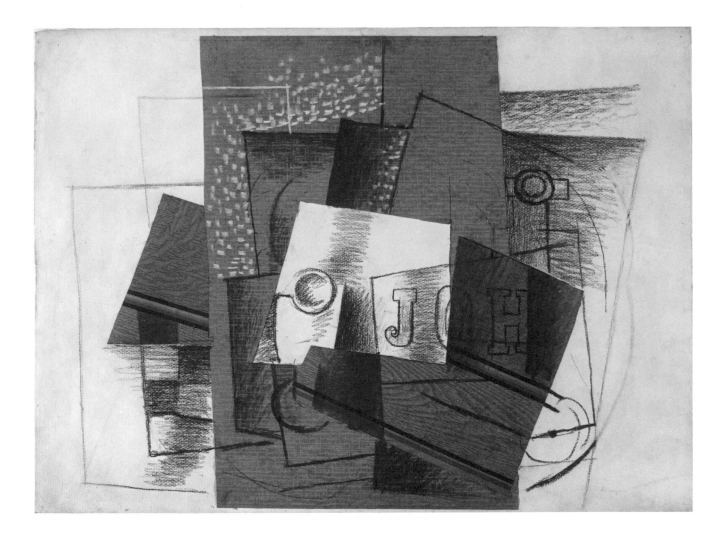

opposite
BRAQUE: *Still Life with Letters.*
1914. Cut-and-pasted papers,
charcoal, and pastel,
20⅜ x 28¾"

GRIS: *Newspaper, Glass, and
Playing Card.* 1916.
Pencil, crayon, and
tempera, 17⅝ x 10¾"

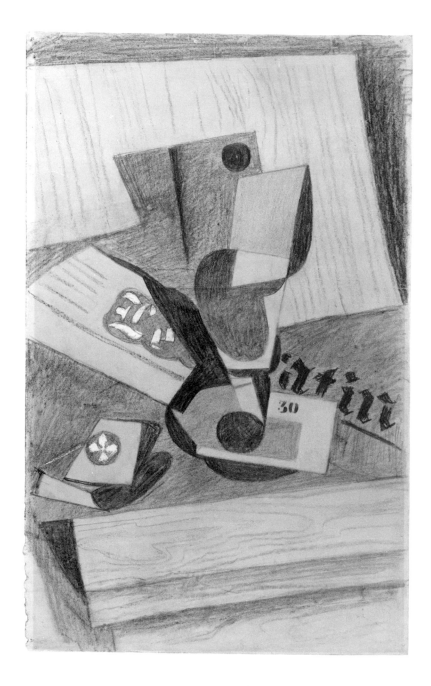

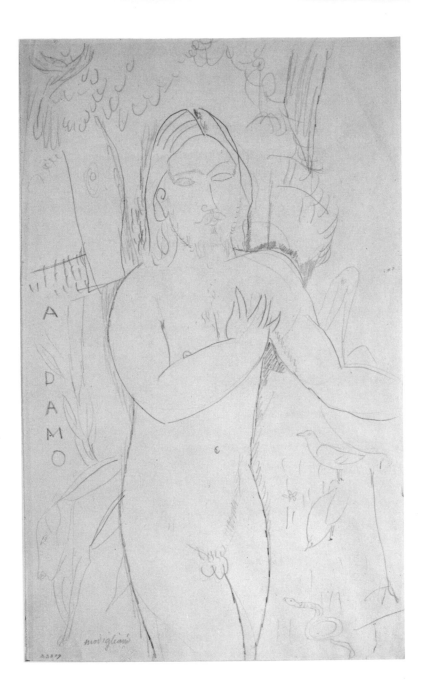

MODIGLIANI: *Adam.*
1915–16. Pencil,
16⅞ x 10¼″

MODIGLIANI: *Harlequinade.*
1915–16. Pencil,
17⅛ x 10⅜"

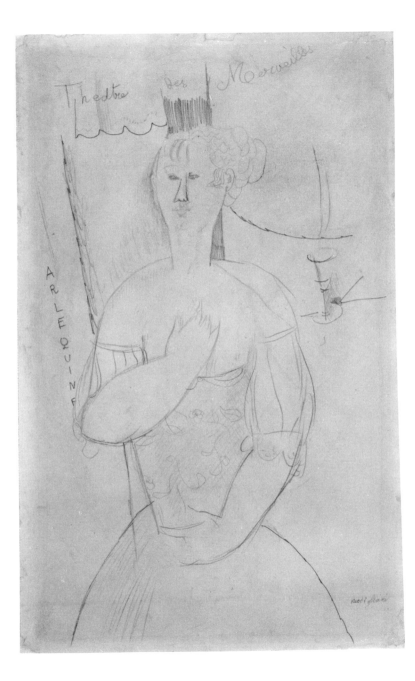

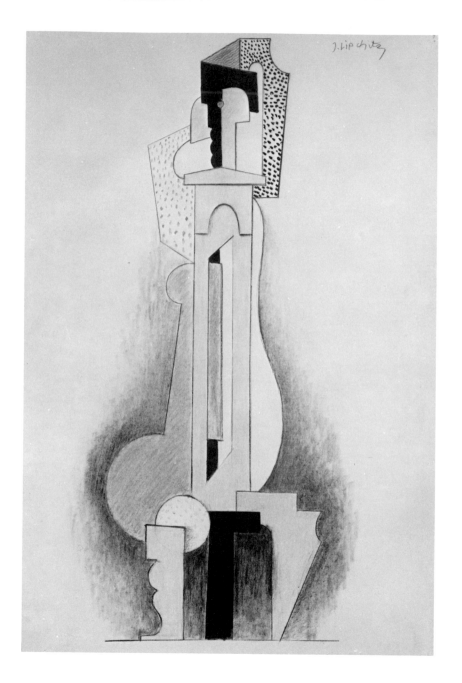

LIPCHITZ: *Seated Nude.*
1915. Crayon, charcoal, pencil,
watercolor, brush and ink,
19⅜ x 12⅞″

KANDINSKY: *The Horseman.*
1916. Watercolor, wash, brush
and ink, pencil, 12¾ x 9⅞″

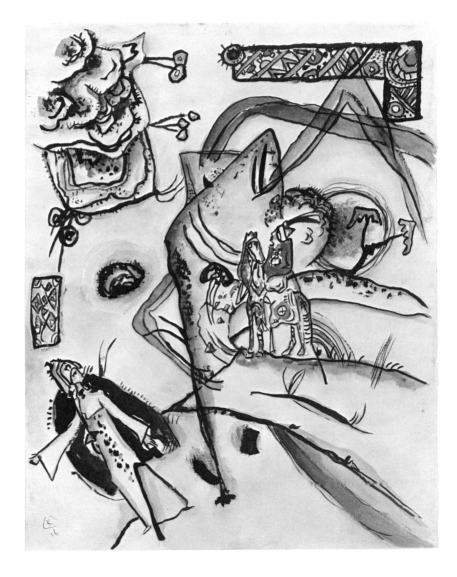

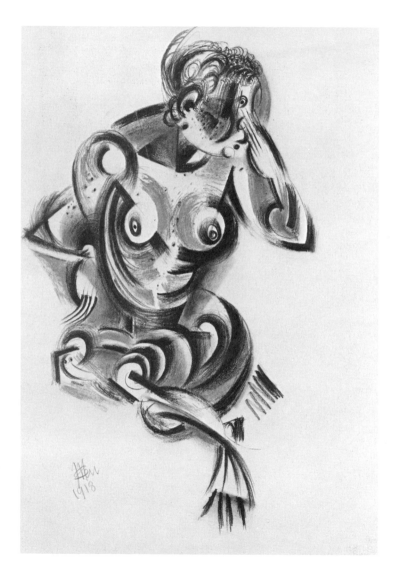

ITTEN: *The Eavesdropper.*
1918. Crayon, charcoal, pencil,
19¾ x 14¼"

opposite
BRANCUSI: *View of the Artist's
Studio.* 1918. Gouache and
pencil, 13 x 16¼"

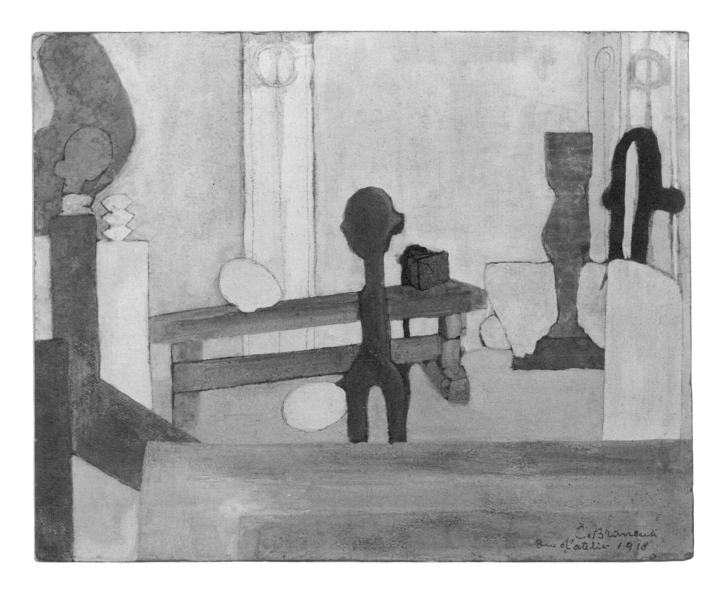

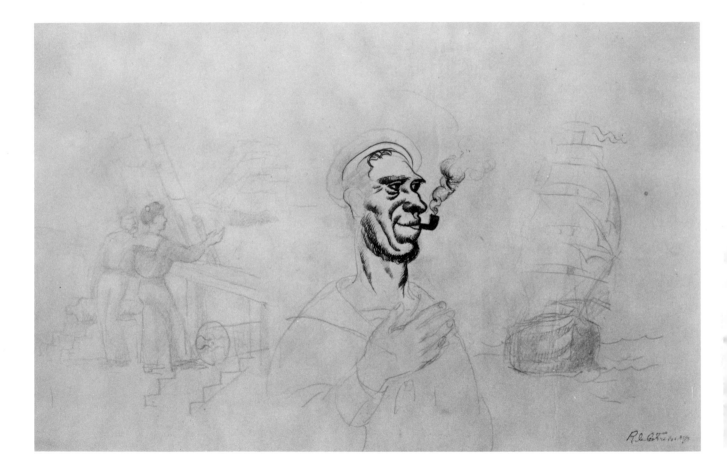

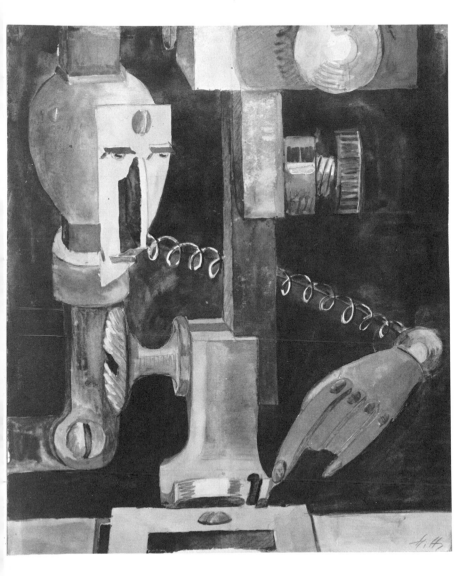

HÖCH: *Man and Machine.*
1921. Watercolor, 11⅜ x 9½"

opposite
SCHLEMMER: *The Figural Cabinet.* 1922. Watercolor, pencil, pen and ink, 12¼ x 17¾"

opposite
LA FRESNAYE: *The Sailor.*
c. 1921. Pencil, pen and ink,
10⅜ x 16⅞"

BAKST: *Porphyrophore.*
1921. Watercolor, pencil, and
metallic paint, 17⅞ x 11⅞"

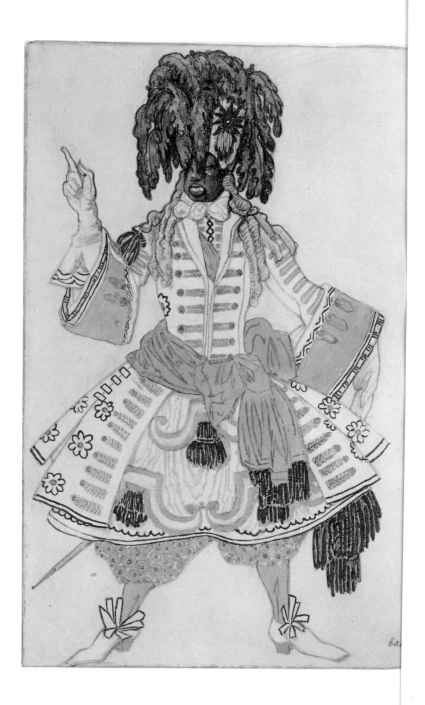

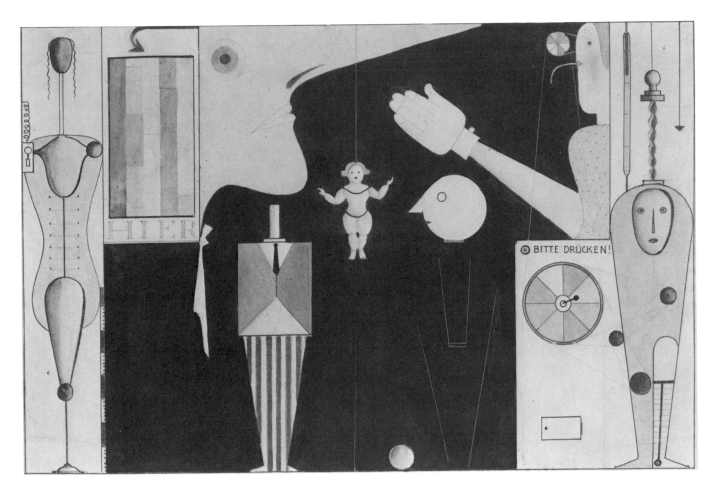

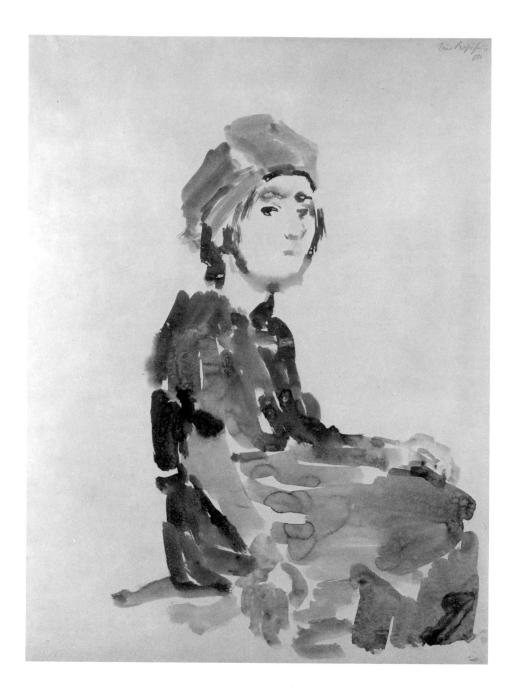

KOKOSCHKA: *Seated Girl.*
1922. Watercolor, 27⅜ x 20⅜"

opposite
CORINTH: *Self-Portrait with
Reflections.* 1925. Crayon,
9⅞ x 12½"

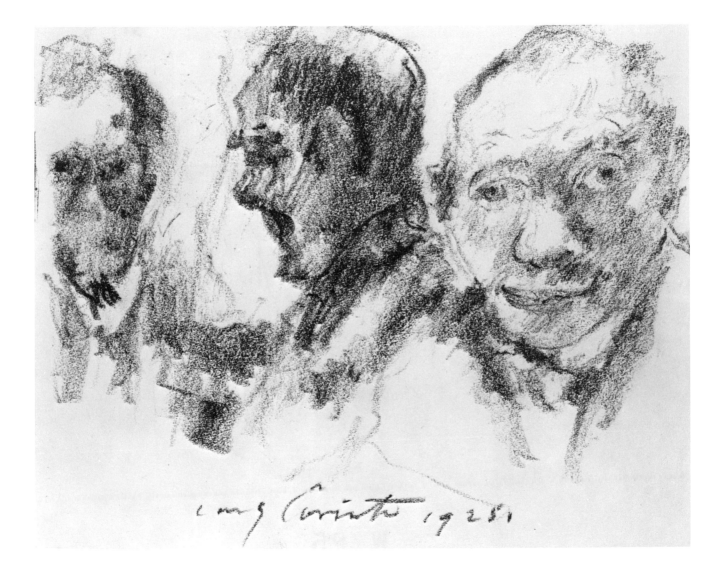

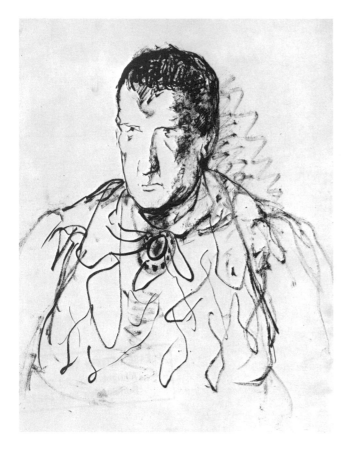 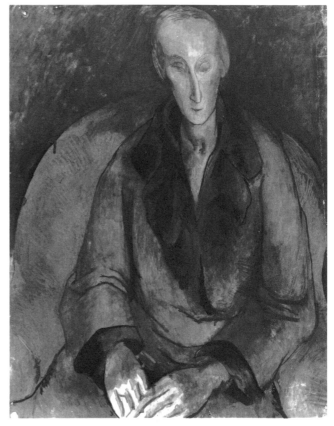

far left
TCHELITCHEW: *Gertrude Stein.*
c. 1927. Brush and ink,
17⅞ x 11½"

left
TCHELITCHEW: *Edith Sitwell.*
c. 1928. Gouache, 25¼ x 19¼"

HOFER: *Two Bathers by the
Shore.* 1928-29. Pencil,
16 x 24⅞"

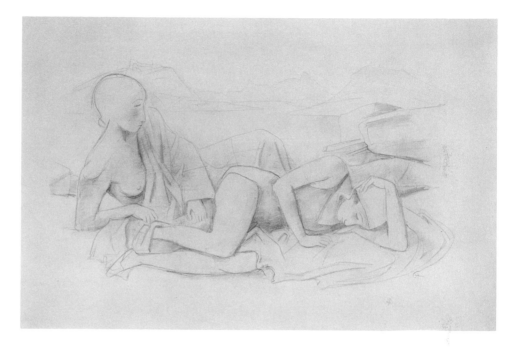

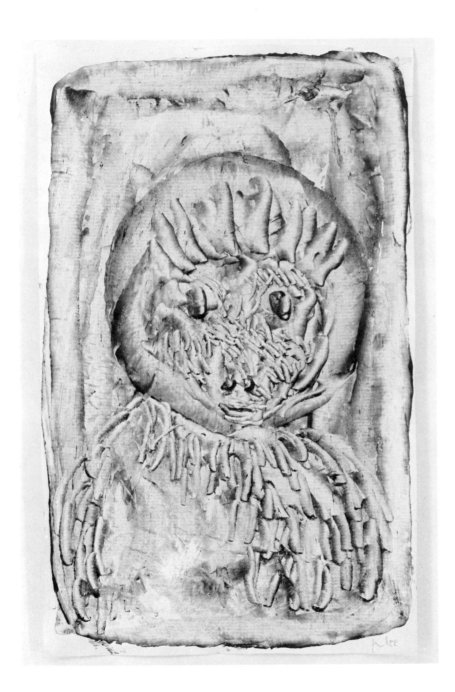

KLEE: *Aged Dwarf*.
1933. Gouache, 13 x 8¼″

opposite
DOMINGUEZ: *Untitled*.
1936–37. Ink transfer,
6⅞ x 9⅞″

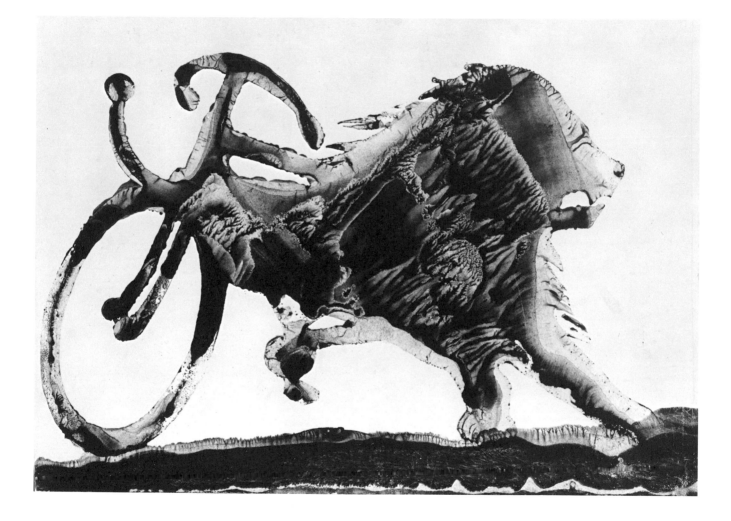

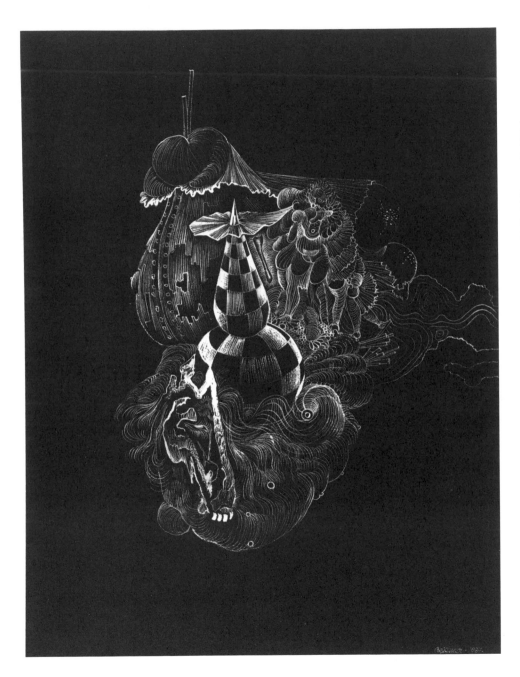

BELLMER: *The Palace of King Ubu.* 1937. Pen and white ink, 11⅞ x 9"

opposite
BELLMER: *The Doll.* 1937. Pen and white ink, 12 x 10"

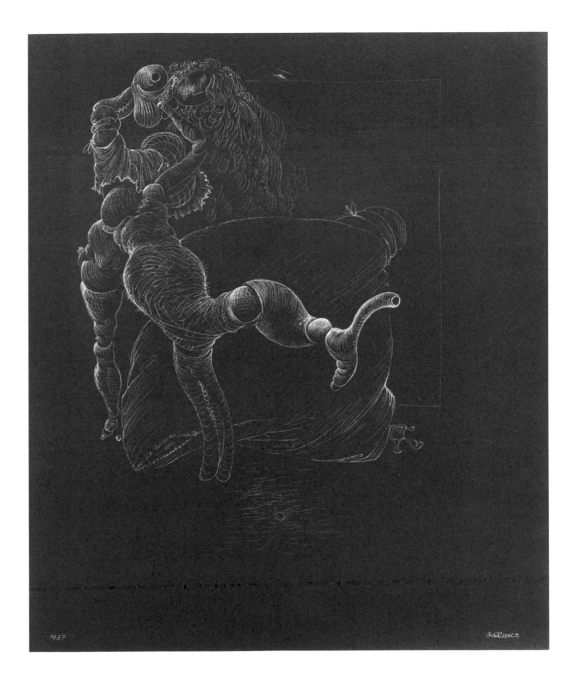

1937 Bellmer

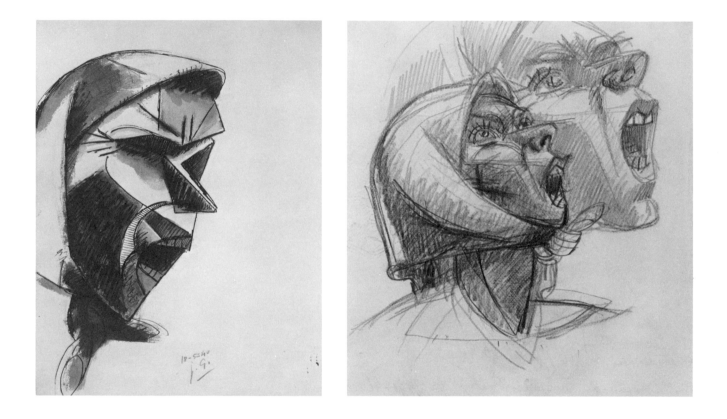

78

far left
GONZALEZ: *Woman Crying.*
1940. Brush, pen and ink,
12⅛ x 9⅜″

left
GONZALEZ: *Woman Crying.*
1941. Pencil, 8 x 6¾″

GRAHAM: *Celia.*
1944–45. Pencil, 23 x 18⅞″

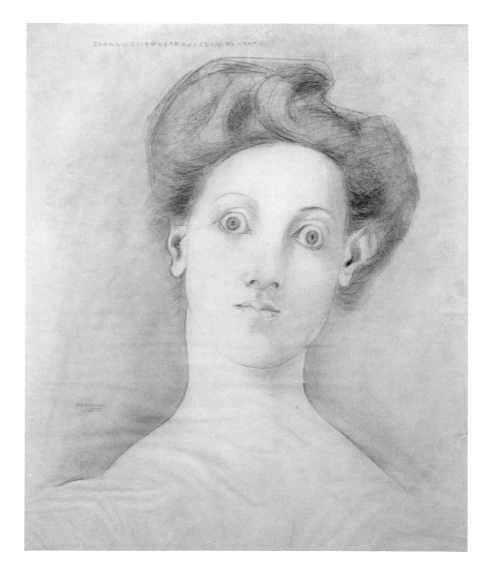

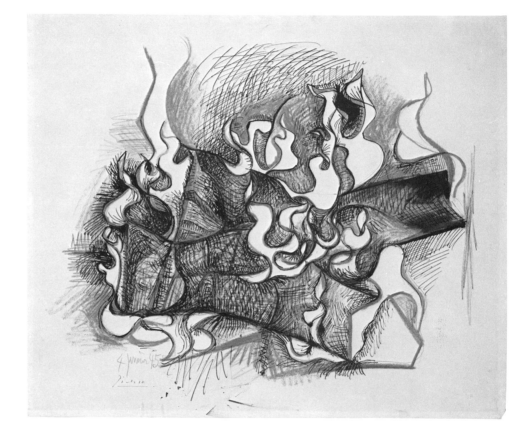

opposite
ROTHKO: *Archaic Idol.*
1945. Gouache, wash, brush,
pen and ink, 21⅞ x 30″

PICASSO: *Burning Logs.*
1945. Crayon, pen and ink,
19½ x 23½″

opposite
BECKMANN: *The Letter.*
1945. Pen and ink, 9 x 13″

right
LAM: *Untitled.*
1946. Wash, pen and ink,
12⅜ x 9½″

far right
LAM: *Untitled.*
1946. Wash, pen and ink,
12⅜ x 9⅝″

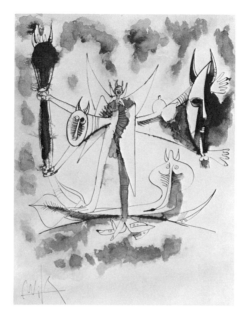

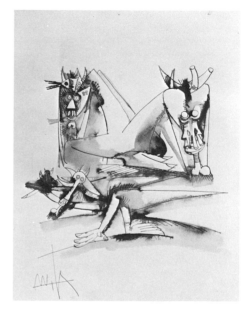

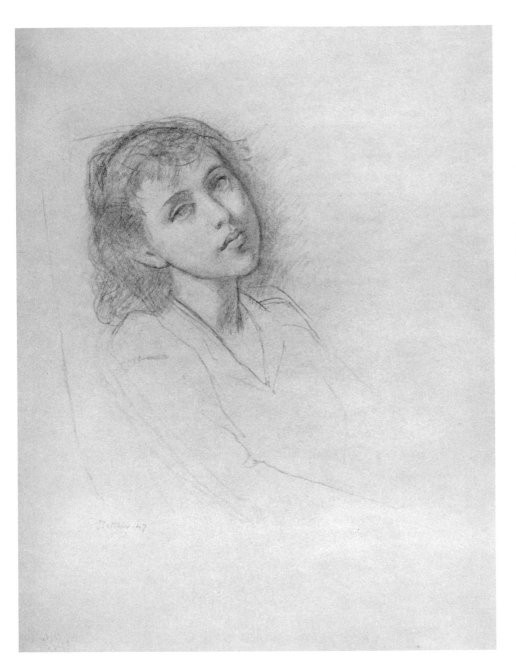

BALTHUS: *A Young Girl.*
1947. Charcoal, 24¾ x 18⅞″

opposite
MOORE: *Woman Knitting
and Girl Reading.* 1947.
Watercolor, pen and ink,
crayon, pencil, 11½ x 9½″

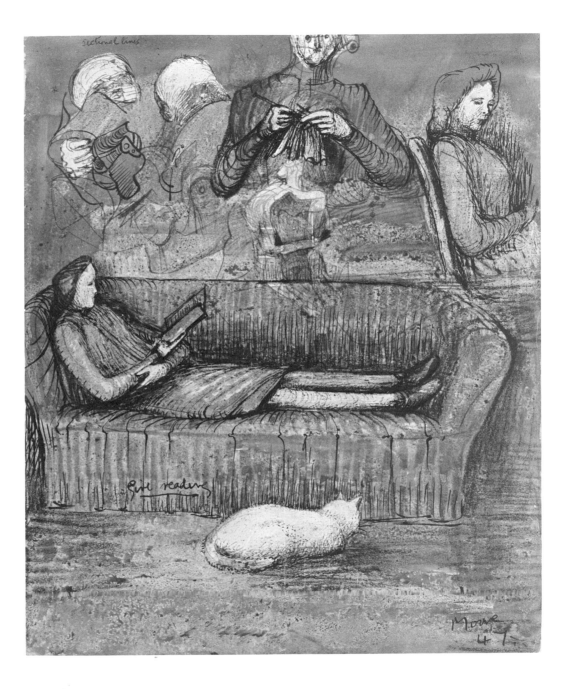

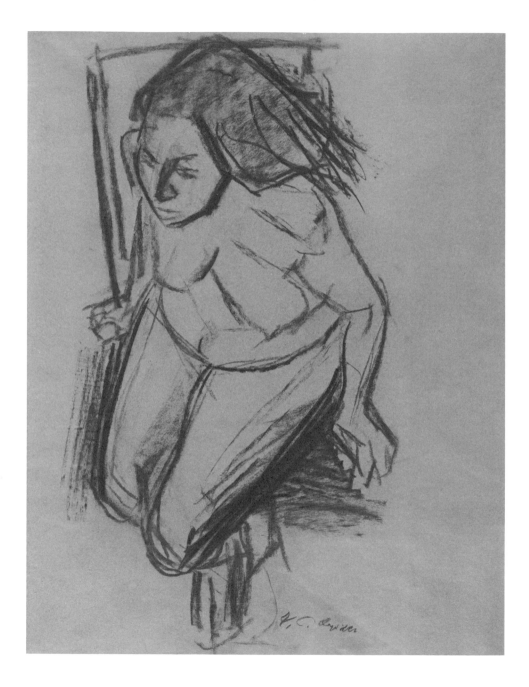

opposite
OROZCO: *Crouching Model.*
1947. Charcoal, 24⅞ x 18⅞″

CADMUS: *Gluttony.*
1949. Pencil and gouache,
25¾ x 14⅞″

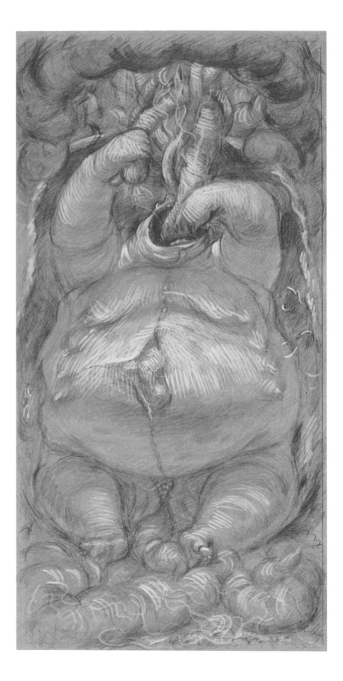

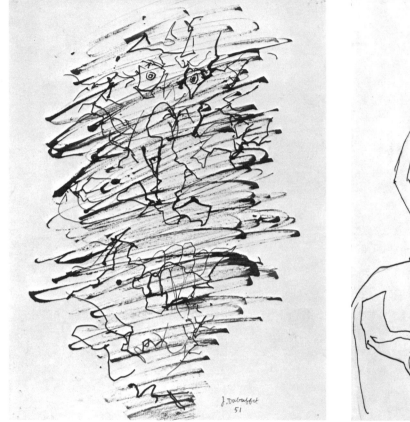

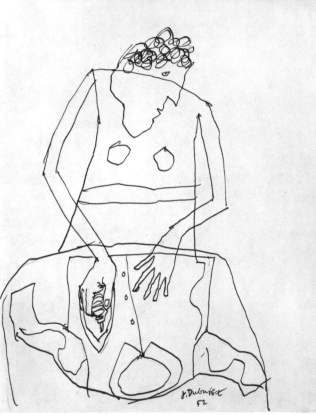

far left
DUBUFFET: *Bowery Bum.*
1951. Reed pen and ink, 12 x 9″

left
DUBUFFET: *Woman Ironing.*
1952. Pencil, pen and ink,
11¾ x 9″

DUBUFFET: *Ties and Whys.*
1952. Pen and ink, 19¾ x 25¾″

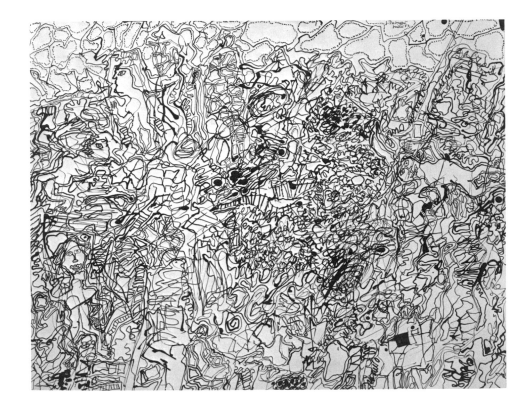

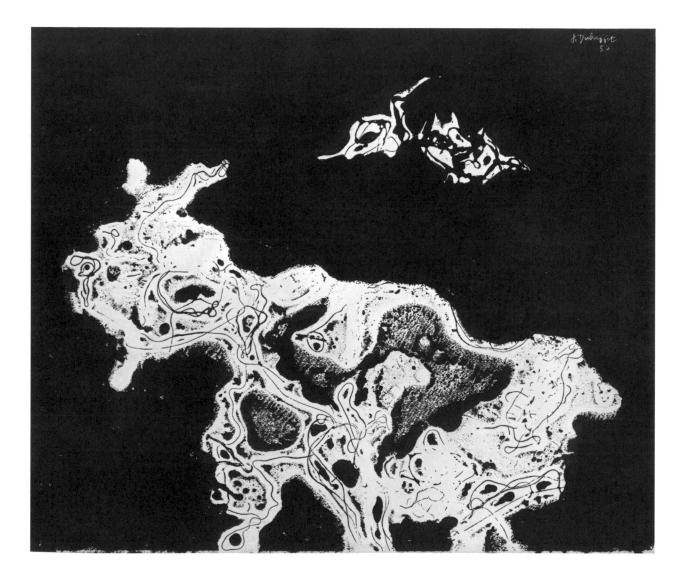

DUBUFFET: *Goat with a Bird.*
1954. Ink transfer, brush and
ink, 18¼ x 22⅜″

DUBUFFET: *Tree.*
1955. Pen, brush and ink, and
wax, 19⅝ x 12⅛″

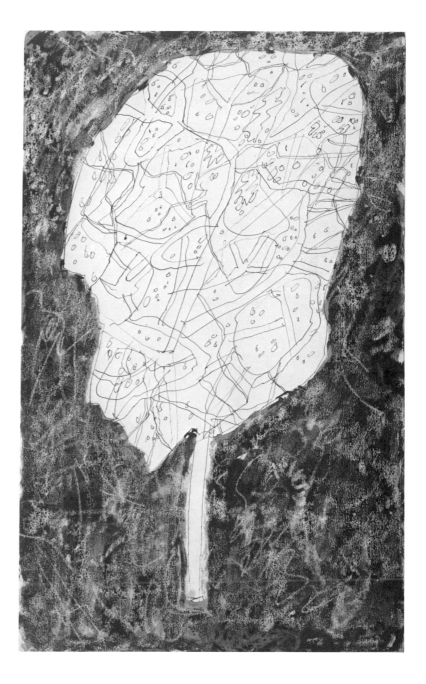

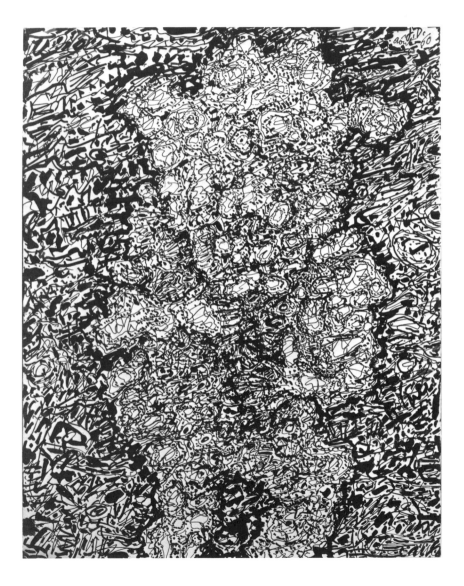

DUBUFFET: *Man with a Hat.*
1960. Pen and ink, 12 x 9⅜"

opposite
DUBUFFET: *Figure in a
Landscape.* 1960.
Pen and ink, 9½ x 12"

JOHNS: *Jubilee.*
1960. Pencil and wash,
28 x 21"

opposite
DELVAUX: *The Astronomers.*
1961. Pen and ink, 13⅜ x 20½"

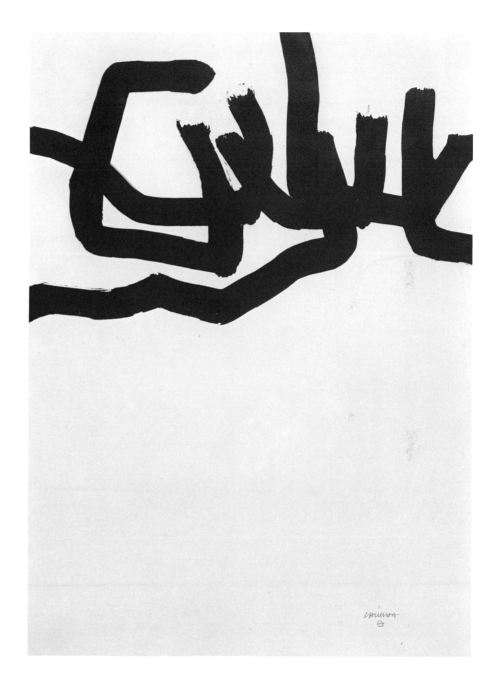

opposite
CASCELLA: *Studies for a Sculpture.* 1964. Pencil, 29⅝ x 39½"

CHILLIDA: *Untitled.* 1966. Brush and ink, 39⅜ x 27⅞"

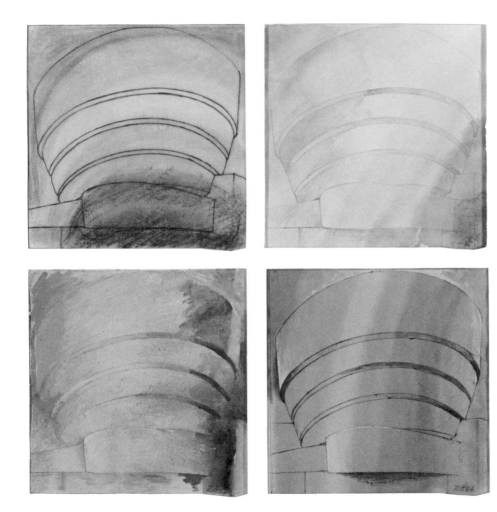

HAMILTON: *The Solomon R. Guggenheim Museum.* 1966

far left, top
Crayon, pen and ink, pencil,
13 ¾ x 13"

left, top
Watercolor and pencil,
13 ½ x 13 ¼"

far left, bottom
Oil, crayon, and pencil,
13 ⅜ x 13 ¼"

left, bottom
Synthetic polymer, with pen
and ink and gouache on
overlay, 9 ⅞ x 9 ⅜"

top
LÓPEZ-GARCÍA: *The Staircase.*
1967. Pencil and wax,
14⅞ x 19½″

bottom
RUSCHA: *Wax.*
1967. Gunpowder, 14½ x 23″

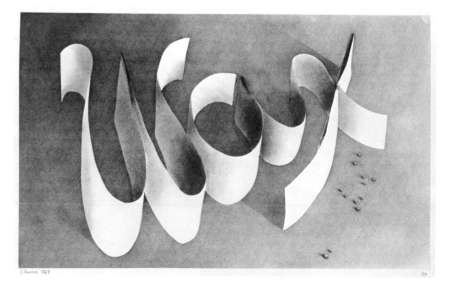

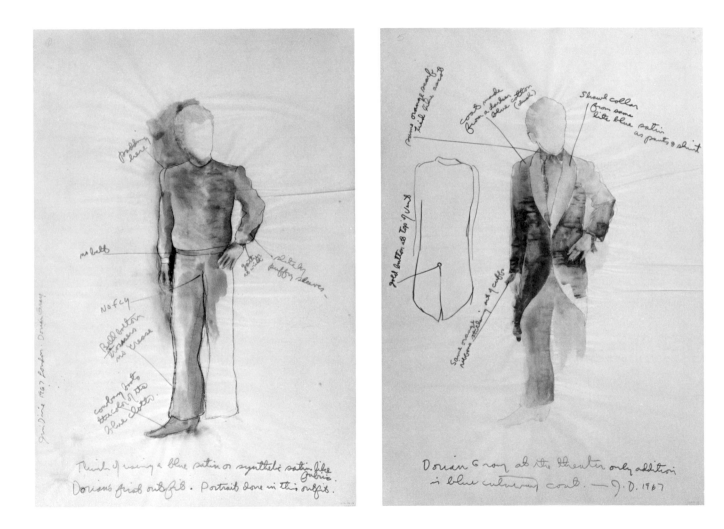

Think of using a blue satin or synthetic satin like fabric. Dorian's first outfit. Portrait done in this outfit.

Dorian Gray at the theater only addition is blue cutaway coat. — J.D. 1967

far left
DINE: *Dorian Gray's First Outfit.* 1967. Gouache, felt-tipped pen, pencil, 29¾ x 20″

left
DINE: *Dorian Gray at the Theater.* 1967. Gouache, felt-tipped pen, pencil, 30 x 19⅞″

DINE: *Lord Henry in Basil Hallward's Studio.* 1967. Pasted paper, gouache, oil pastel, felt-tipped pen, pen and ink, pencil, 30 x 20″

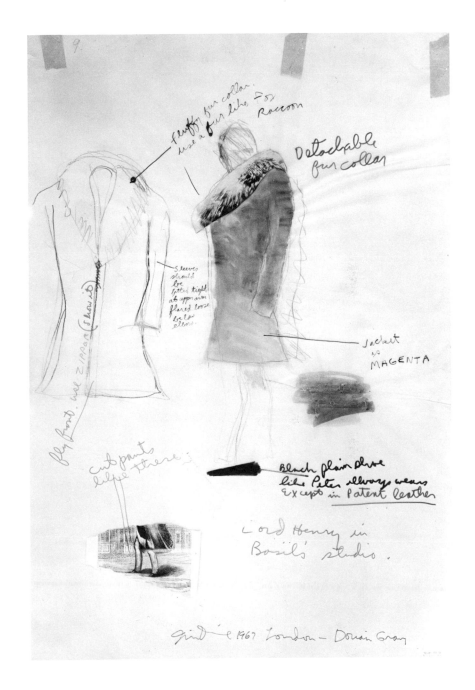

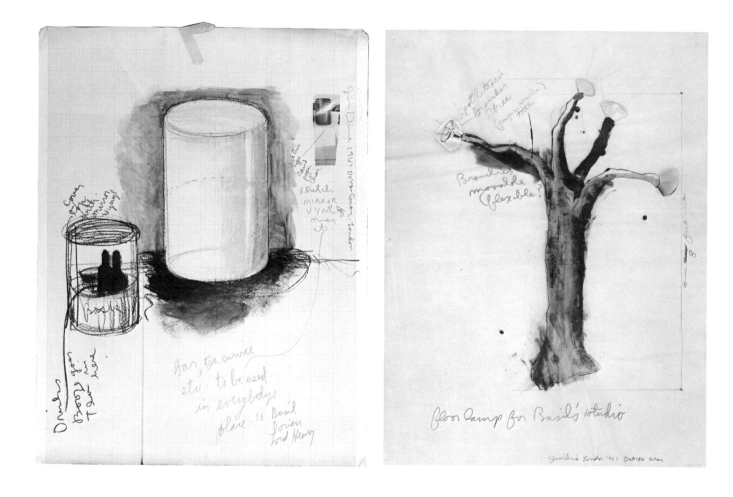

far left
DINE: *Bar, Tea Service, etc., to be Used in Everybody's Place.* 1967. Pasted paper, oil pastel, gouache, felt-tipped pen, pen and ink, 39⅛ x 29½"

left
DINE: *Floor Lamp for Basil Hallward's Studio.* 1967. Pasted paper, gouache, felt-tipped pen, pen and ink, pencil, 27⅜ x 20"

DINE: *Sibyl Vane as Juliet.* 1967. Pasted paper, gouache, felt-tipped pen, pen and ink, pencil, 29⅞ x 20"

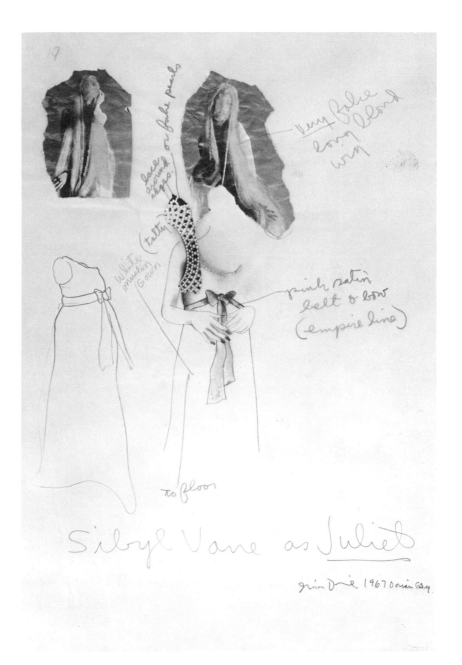

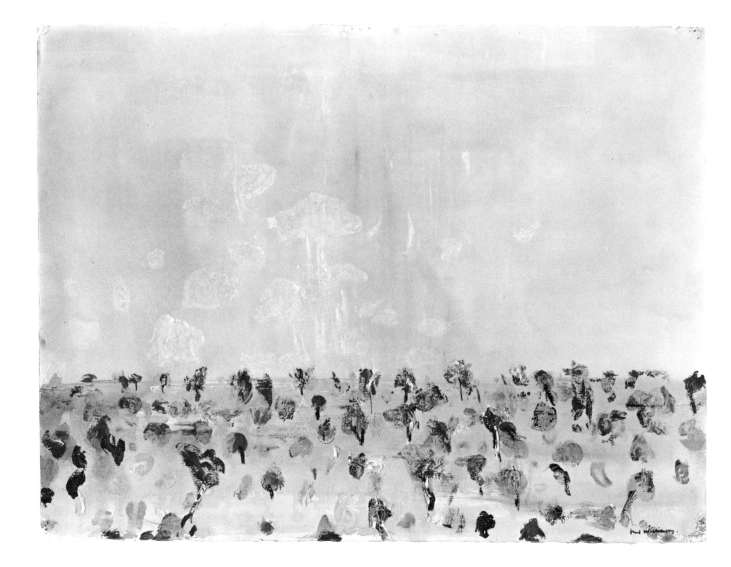

opposite
WILLIAMS: *Desert Dust Storm,
Tibooburra.* 1967. Gouache,
22½ x 30″

WILLIAMS: *Flinders Island.*
1968. Gouache, 22⅜ x 30¼″

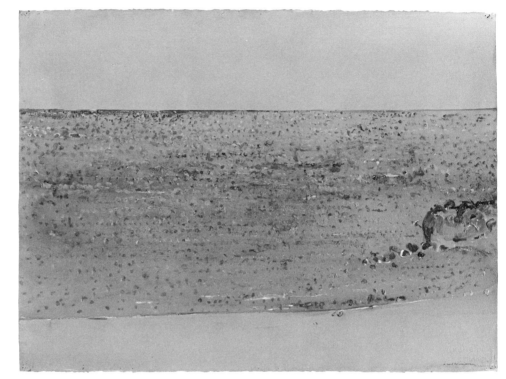

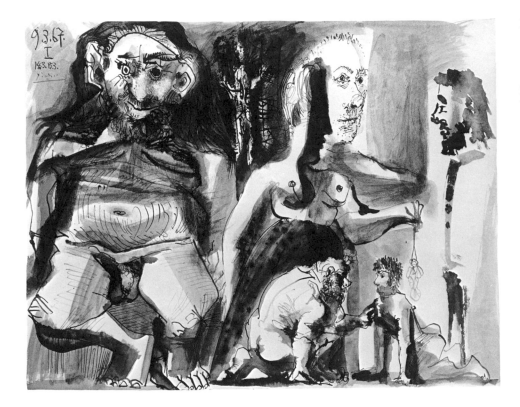

PICASSO: *Figures.*
1967. Wash, brush, pen and ink,
19⅜ x 25½″

opposite
PICASSO: *The Pool.*
1968. Pencil, 23 x 30⅝″

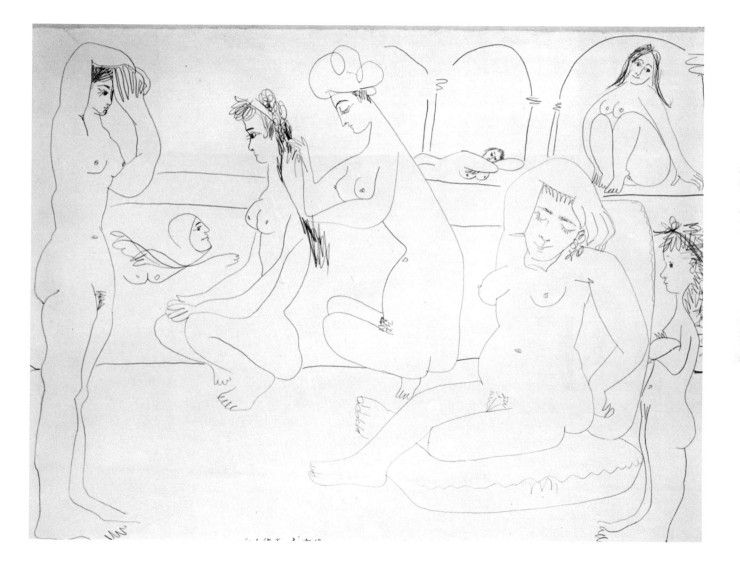

CATALOG OF THE COLLECTION

In the listings below, dates enclosed in parentheses do not appear on the drawings themselves. All works are on paper. Sheet dimensions are given in inches and centimeters, height preceding width. The page on which a work is illustrated is indicated at the end of the entry.

ALECHINSKY, Pierre. Belgian, born 1927. In France since 1955

1 *Baron Ensor's Showcase*. 1968. Brush and ink, 26¼ x 28½" (66.6 x 72.3 cm)

APPEL, Karel. Dutch, born 1921. In France since 1950

2 *Beast*. 1956. Brush and ink, 9½ x 12⅜" (24 x 31.9 cm)

ATKINSON, Lawrence. British, 1873–1931

3 *Composition*. (c. 1914.) Pencil and pastel, 31¾ x 21¾" (80.3 x 55.1 cm). Page 57

BAKST, Léon. Russian, 1866–1924. To France 1916

4 *The Firebird*. (1913.) Watercolor, pencil, and metallic paint, 26⅜ x 19⅜" (67.4 x 49 cm). Page 55

5 *Porphyrophore*. 1921. Watercolor, pencil, and metallic paint, 17⅝ x 11⅝" (44.6 x 29.3 cm). Page 67

BALTHUS (Baltusz Klossowski de Rola). French, born 1908

6 *A Young Girl*. 1947. Charcoal, 24¾ x 18⅞" (62.7 x 48 cm). Page 84

BARLACH, Ernst. German, 1870–1938

7 *A Beggar*. 1922. Charcoal, 20 x 14¾" (50.9 x 37.2 cm)

BECKMANN, Max. German, 1884–1950

8 *The Letter*. October 13, 1945. Pen and ink, 9 x 13" (22.9 x 33 cm). Page 82

BELL, Vanessa. British, 1879–1961

9 *Composition*. (c. 1914.) Gouache and pasted paper, 21¾ x 17¼" (55.1 x 43.7 cm)

10 *Decanter with Fruit*. (1918.) Watercolor, brush and ink, traces of pencil, 10 x 7" (25.4 x 17.9 cm)

BELLMER, Hans. German, born Poland. 1902–1975. To France 1938

11 *The Doll*. 1937. Pen and white ink on black paper, 12 x 10" (30.4 x 25.2 cm). Page 77

12 *The Palace of King Ubu*. 1937. Pen and white ink on black paper, 11⅞ x 9" (30 x 22.9 cm). Page 76

13 *Studies of a Young Girl.* (1937.) Pen and white ink on black paper, 11⅞ x 9″ (30 x 22.9 cm)

BITTLEMAN, Arnold. American, born 1933

14 *Mr. Mapelli's Garden, III.* (1958-60.) Pen and ink, 74½ x 39¼″ (188.5 x 99.6 cm)

BLAKE, Peter. British, born 1932

15 *Little Sonny Summer.* 1969. Watercolor, tempera, pen and ink, 18¼ x 11½″ (46.3 x 29.4 cm)

BOGOMAZOV, Alexander. Russian, 1880–1930

16 *Woman Reading.* (1914-15.) Charcoal, 16 x 12⅝″ (40.6 x 32.1 cm)

BOMBERG, David. British, 1890-1957

17 *The Return of Ulysses.* 1913. Charcoal, 12⅛ x 18½″ (30.6 x 46.7). Page 52

18 *Family Bereavement.* (1913.) Charcoal, 21⅞ x 18⅜″ (55.5 x 46.7 cm). Page 53

BOURDELLE, Emile-Antoine. French, 1861-1929

19 *Isadora Duncan.* (1912.) Wash, pen and ink, 12⅛ x 7¾″ (30.7 x 19.6 cm)

BRANCUSI, Constantin. French, born Rumania. 1876-1957. To France 1904

20 *View of the Artist's Studio.* 1918. Gouache and pencil, 13 x 16¼″ (32.8 x 41.1 cm). Page 65

BRAQUE, Georges. French, 1882-1963

21 *Still Life with Letters.* (1914.) Cut-and-pasted papers, charcoal, and pastel, 20⅜ x 28¾″ (51.7 x 73 cm). Page 58

BRICE, William. American, born 1921

22 *Man in a Cap.* 1956. Charcoal, pen and brush and ink, and white chalk, 25 x 19¼″ (63.5 x 48.4 cm)

CADMUS, Paul. American, born 1904

23 *Gluttony.* (1949.) Pencil and gouache, 25¾ x 14⅞″ (65.2 x 37.7 cm). Page 87

CASCELLA, Andrea. Italian, born 1920

24 *Studies for a Sculpture.* (1964.) Pencil, 29⅜ x 39½″ (75.3 x 100.4 cm). Page 96

CHAGALL, Marc. French, born Russia 1887. In France 1910-14; and permanently after 1923

25 *Golgotha.* 1912. Gouache, watercolor, and pencil, 18⅝ x 23⅜″ (47.4 x 59.2 cm). Page 49

CHILLIDA, Eduardo. Spanish, born 1924

26 *Untitled.* (1966.) Brush and ink, 39⅜ x 27⅝″ (100.1 x 70.2 cm). Page 97

CORINTH, Lovis. German, 1858-1925

27 *The Artist's Wife Asleep.* 1903. Pencil, 13⅞ x 13½″ (35.3 x 34.2 cm). Page 38

28 *Self-Portrait with Reflections*. 1925. Crayon, 9⅞ x 12½" (25.2 x 31.5 cm). Page 71

DAVIES, Arthur B. American, 1862–1928

29 *Nude*. (c. 1910.) Crayon and gouache, 14¾ x 10⅞" (37.4 x 27.6 cm)

DELAUNAY, Sonia. French, born Ukraine 1885

30 *Miss Mouth and Mr. Eye*. (1923.) Watercolor, traces of pencil, 12¾ x 9⅝" (32.4 x 24.5 cm)

31 *Pajamas for Tristan Tzara*. 1923. Watercolor, traces of pencil, 12¼ x 9" (31 x 22.8 cm)

DELVAUX, Paul. Belgian, born 1897

32 *The Astronomers*. March 1961. Pen and ink, traces of pencil, 13⅜ x 20½" (33.9 x 51.9 cm). Page 95

DELVILLE, Jean. Belgian, 1867–1953

33 *Expectation*. (1903.) Pencil and charcoal, 39¾ x 17½" (100.8 x 44.5 cm). Page 39

DERAIN, André. French, 1880–1954

34 *The Grove*. (1912.) Conté crayon, 25½ x 19⅞" (64.7 x 50.3 cm)

DICKINSON, Preston. American, 1891–1930

35 *Grain Elevators, Omaha*. (1924.) Pen and ink, charcoal, pencil, and pastel, 20⅛ x 14" (50.8 x 35.6 cm)

DINE, Jim. American, born 1935

The following ten costume and stage designs, from a series of thirty-one, were executed November 1967 through February 1968 for an unrealized production of *The Picture of Dorian Gray,* adapted for the stage by Jim Dine and Robert Kidd from the novel by Oscar Wilde.

36 *Dorian Gray's First Outfit*. 1967. Gouache, felt-tipped pen, pencil, 29¾ x 20" (75.6 x 50.8 cm). Page 100

37 *Dorian Gray at the Theater*. 1967. Gouache, felt-tipped pen, pencil, 30 x 19⅞" (76.2 x 50.5 cm). Page 100

38 *Dorian Gray's Multicolored Vinyl Cloak*. 1967. Gouache, felt-tipped pen, pen and ink, pencil, 25½ x 20" (64.8 x 50.8 cm)

39 *Dorian Gray as His Dress Gets More Eccentric*. 1967. Gouache, oil pastel, felt-tipped pen, pencil, 29¾ x 20" (75.6 x 50.8 cm)

40 *Dorian Gray's Last Costume*. 1967. Pasted paper, gouache, felt-tipped pen, ink, pencil, 29⅞ x 20" (75.8 x 50.8 cm)

41 *Lord Henry in Basil Hallward's Studio*. 1967. Pasted paper, gouache, oil pastel, felt-tipped pen, pen and ink, pencil, 30 x 20" (76.2 x 50.8 cm). Page 101

42 *Basil Hallward's Costume for First Scene in Studio*. 1967. Pasted paper, gouache, oil pastel, felt-tipped pen, brush, pen and ink, pencil, 29⅜ x 20" (74.4 x 50.8 cm)

43 *Sibyl Vane as Juliet*. 1967. Pasted paper, gouache, felt-tipped pen, pen and ink, pencil, 29⅞ x 20″ (75.8 x 50.8 cm). Page 103

44 *Floor Lamp for Basil Hallward's Studio*. 1967. Pasted paper, gouache, felt-tipped pen, pen and ink, pencil, 27⅜ x 20″ (69.5 x 50.8 cm). Page 102

45 *Bar, Tea Service, etc., to be Used in Everybody's Place*. 1967. Pasted paper, oil pastel, gouache, felt-tipped pen, pen and ink, 39⅛ x 29½″ (99.3 x 74.9 cm). Page 102

van DOESBURG, Theo (C. E. M. Küpper). Dutch, 1883–1931

46 *Circular Composition: Counter-Construction*. (c. 1923.) Gouache, ink wash, and pencil, 21 x 18½″ (53.3 x 46.9 cm)

DOMINGUEZ, Oscar. French, born Spain. 1906–1957. To France 1927

47 *Untitled*. (1936–37.) Ink transfer (decalcomania), 6⅝ x 9⅞″ (16.6 x 24.9 cm). Page 75

48 *Untitled*. (1936–37.) Ink transfer (decalcomania), 6⅛ x 8⅝″ (15.4 x 21.8 cm)

DUBUFFET, Jean. French, born 1901
"Loreau" refers to the *Catalogue des travaux de Jean Dubuffet*, edited by Max Loreau, Paris; 27 volumes published to date.

49 *Shadows in the Pine Forest*. June 3, 1944. Pen and ink, 5⅜ x 6⅞″ (13.6 x 17.5 cm). Loreau I, 265

50 *Personage*. June 29, 1944. Ink over gesso incised with pen, 11¼ x 6⅝″ (28.3 x 16.7 cm). From the series "Marionettes of the City and Country." Loreau I, 296

51 *Michel Tapié*. (August) 1946. Gouache and charcoal, 16⅜ x 10⅞″ (41.6 x 27.5 cm). From the series "Portraits: More Beautiful Than They Think." Loreau III, 11

52 *The Visitors Welcomed*. August 1949. Pen and ink and wash, 9⅞ x 12¾″ (24.9 x 32.4 cm). From the series "Grotesque Landscapes." Loreau V, 87

53 *Subway*. (September or October) 1949. Incised ink on gesso, 12¾ x 9¼″ (32.1 x 23.5 cm). From the series "Metro and Metromania." Loreau V, 117

54 *Subway*. (September or October) 1949. Incised ink on gesso, 12⅝ x 9⅞″ (32 x 24.8 cm). From the series "Metro and Metromania." Loreau V, 118

55 *Nude*. (November) 1950. Pen, reed pen and ink, 10⅝ x 8⅜″ (27 x 21.2 cm). From the series "Corps de dames." Loreau VI, 183

56 *Nude*. (November) 1950. Pen and ink, 10¾ x 8⅜″ (27.2 x 21.1 cm). From the series "Corps de dames." Loreau VI, 168

57 *Nude*. (June–December) 1950. Reed pen and ink, and wash, 12¾ x 9⅞″ (32.4 x 24.9 cm). From the series "Corps de dames." Loreau VI, 184

58 *Table Laden with Objects*. March 17, 1951. Pen, reed pen and ink, 12¾ x 10¼″ (32.4 x 26 cm). From the series "Landscape Tables." Loreau VII, 13

59 *Bowery Bum*. (December) 1951. Reed pen and ink, 12 x 9″ (30.4 x 22.7 cm). From the series "New York Drawings." Loreau VII, 112. Page 88

60 *Evolving Portrait.* (January) 1952. Reed pen and ink, 18¾ x 13¾″ (47.5 x 34.9 cm).
From the series "New York Drawings." Loreau VII, 162

61 *Woman Ironing.* 1952. Pencil, pen and ink, 11¾ x 9″ (29.7 x 22.6 cm).
From the series "New York Drawings." Loreau VII, 109. Page 88

62 *Landscape.* June 1952. Brush, pen, reed pen and ink, 17⅞ x 23¾″ (45.3 x 60.2 cm).
From the series "Radiant Lands." Loreau VII, 258

63 *Ties and Whys: Landscape with Figures.* July 1952. Pen and ink, 19¾ x 25¾″
(50 x 65.2 cm). From the series "Radiant Lands." Loreau VII, 267. Page 89

64 *Cow.* (December) 1954. Pen and ink and wash, 8⅞ x 11⅞″ (22.3 x 30.1 cm).
From the series "Cows, Grass, Foliage." Loreau X, 139

65 *Cow.* December 1954. Pen and ink, 12¾ x 9⅞″ (32.4 x 25 cm).
From the series "Cows, Grass, Foliage." Loreau X, 155

66 *Goat with a Bird.* 1954. Ink transfer, brush and ink, 18¼ x 22⅜″ (46.2 x 56.7 cm).
From the first series of "Imprints." Loreau IX, 69. Page 90

67 *Donkey and Cart.* (May) 1955. Pen and ink, 9⅜ x 12⅝″ (23.6 x 32 cm).
From the series "Carts, Gardens." Loreau XI, 78

68 *Foot of a Post in Front of a Wall.* June 1955. Pencil, 12⅝ x 9¼″ (32 x 23.5 cm).
From the series "Carts, Gardens." Loreau XI, 99

69 *Tree.* (c. June) 1955. Pen, brush and ink, and wax, 19⅝ x 12⅛″ (49.8 x 30.6 cm).
From the series "Carts, Gardens." Loreau XI, 100. Page 91

70 *Stone Transcription.* (November) 1958. Pen and ink, 14¼ x 9⅛″ (36.1 x 23 cm).
From the series "Texturologies." Loreau XIV, 111

71 *Textural Transcription.* (November) 1958. Pen and ink, 9⅛ x 14¼″ (23 x 36.2 cm).
From the series "Texturologies." Loreau XIV, 112

72 *Figure in a Landscape.* July 1960. Pen and ink, 9½ x 12″ (23.3 x 30.3 cm).
From the series "Drawings in India Ink and Wash." Loreau XVIII, 163. Page 93

73 *Landscape with Figure.* August 1960. Pen and ink, 15⅝ x 12⅞″ (39.7 x 32.7 cm).
From the series "Drawings in India Ink and Wash." Loreau XVIII, 183

74 *Man with a Hat in a Landscape.* August 1960. Pen and ink, 12 x 9⅜″ (30.4 x 23.7 cm).
From the series "Drawings in India Ink and Wash." Loreau XVIII, 172. Page 92

75 *Pisseur à droite, X.* (August 28) 1961. Pen and ink, 10⅝ x 8¼″ (26.9 x 21 cm).
From the series "Pisseurs." Loreau XIX, 135

76 *Figure, Black Background.* October 3, 1961. Brush, pen and ink, 13¼ x 9⅞″
(33.5 x 25 cm). From the series "One Episode from 'Legends': Exodus." Loreau
XIX, 185

77 *Landscape with Three Figures.* (November 26) 1961. Pasted papers, gouache, brush
and ink, 21⅝ x 26⅛″ (54.8 x 66.2 cm). From the series "Legends." Loreau XIX, 227

78 *Landscape with Three Figures.* December 5, 1961. Pasted papers, gouache, brush
and ink, 21⅝ x 26⅛″ (54.8 x 66.2 cm). From the series "Legends." Loreau XIX, 232

EPSTEIN, Jacob. British, born U.S.A. 1880-1959. To England 1905

79 *Rock Driller.* (1913.) Chalk, 27⅜ x 17⅛" (69.6 x 43.6 cm). Page 54

FEININGER, Lyonel. American, 1871-1956. In Germany 1887-1936

80 *Arceuil, II.* March 19, 1915. Pen and ink, and crayon, 12 x 9⅜" (30.3 x 23.6 cm)

81 *Street in Arceuil.* March 30, 1915. Watercolor, gouache, pen and ink, 11¼ x 9½" (28.5 x 24 cm)

82 *The Town of Legefeld, I.* April 7, 1916. Pen and ink, charcoal, 9½ x 12½" (24 x 31.6 cm). Frontispiece

83 *Ulla.* January 8, 1924. Watercolor, pen and ink, 14 x 17" (35.6 x 43.4 cm)

FRY, Roger Eliot. British, 1866-1934

84 *Vanessa Bell Painting.* (c. 1914.) Pen and ink, 9⅞ x 14⅝" (25 x 37.2 cm)

GAUDIER-BRZESKA, Henri. French, 1891-1915. To England 1910

85 *Standing Nude.* (1913.) Chalk, 15 x 10⅛" (38.1 x 25.7 cm). Page 54

GIACOMETTI, Alberto. Swiss, 1901-1966. To Paris 1922

86 *An Interior.* 1955. Pencil, 19¾ x 12⅞" (50 x 32.6 cm)

GLEIZES, Albert. French, 1881-1953

87 *Houses in a Valley.* (c. 1910.) Watercolor and pencil, 12¼ x 9⅜" (31 x 23.9 cm)

88 *Landscape with Bridge and Viaduct.* 1910-12. Pen and ink, 6⅝ x 5⅜" (16.9 x 13.2 cm)

GONTCHAROVA, Natalie. Russian, 1881-1962. To Paris 1915

89 *Electricity.* 1912. Pencil, 13¾ x 9⅞" (35 x 24.9 cm)

GONZALEZ, Julio. Spanish, 1876-1942. To Paris 1900

90 *Woman Crying.* May 18, 1940. Brush, pen and ink, 12⅝ x 9⅜" (32 x 24.2 cm). Page 78

91 *Woman Crying.* (1941.) Pencil, 8 x 6¾" (20.1 x 17 cm). Page 78

GORE, Spencer Frederick. British, 1878-1914

92 *Inez and Taki.* (1910.) Pastel and pencil, 8⅛ x 11⅛" (20.6 x 28.4 cm). Page 44

GRAHAM, John D. American, born Ukraine. 1886-1961. To U.S.A. 1920

93 *Celia.* 1944-45. Pencil, 23 x 18⅞" (58.2 x 47.7 cm). Page 79

GRANT, Duncan James Corrowr. British, born 1885

94 *Vanessa Bell Painting.* (1918.) Pencil, 10¾ x 9½" (27.3 x 24 cm)

GRIS, Juan. Spanish, 1887-1927. To France 1906

95 *Newspaper, Glass, and Playing Card.* (1916.) Pencil, crayon, and tempera, 17⅞ x 10¾" (44.7 x 27.2 cm). Page 59

GROSZ, George. American, 1893–1959. Born and died in Germany. In U.S.A. 1932–59

96 *An Orderly.* (1930.) Watercolor, pen and ink, 26¼ x 19″ (66.7 x 48.3 cm)

97 *Three Soldiers.* (1930.) Watercolor, pen and ink, 20⅝ x 27½″ (52.4 x 69.9 cm)

HAMILTON, Richard. British, born 1922

 The Solomon R. Guggenheim Museum. 1966.

98 Crayon, pen and ink, pencil, 13¾ x 13″ (33.8 x 33 cm);

99 watercolor and pencil, 13½ x 13¼″ (34.3 x 33.6 cm);

100 oil, crayon, and pencil, 13⅝ x 13¼″ (34.7 x 33.6 cm);

101 synthetic polymer, with pen and ink and gouache on overlay, 9⅞ x 9⅜″ (25 x 23.8 cm). Page 98

HARTLEY, Marsden. American, 1877–1943

102 *Prayer on Park Avenue.* (c. 1939.) Crayon, 27⅞ x 21¾″ (70.8 x 55.3 cm)

HÖCH, Hannah. German, born 1889

103 *Man and Machine.* 1921 (verso). Watercolor, traces of pencil, 11⅜ x 9½″ (29 x 24.2 cm). Page 68

HOFER, Carl. German, 1878–1955

104 *Two Bathers by the Shore.* (1928–29.) Pencil, 16 x 24⅞″ (40.7 x 63.2 cm). Page 73

ITTEN, Johannes. Swiss, 1888–1967

105 *The Eavesdropper.* 1918. Crayon, charcoal, pencil, 19¾ x 14¼″ (50.1 x 36 cm). Page 64

JOHNS, Jasper. American, born 1930

106 *Jubilee.* (1960.) Pencil and graphite wash, 28 x 21″ (71.1 x 53.3 cm). Page 94

KANDINSKY, Wassily. Russian, 1866–1944. To France 1933

107 *The Horseman.* 1916. Watercolor, wash, brush and ink, pencil, 12¾ x 9⅞″ (32.3 x 24.9 cm). Page 63

KIRCHNER, Ernst Ludwig. German, 1880–1938

108 *A Couple.* (1909.) Pencil, 13⅝ x 17″ (34.5 x 43.1 cm). Page 43

KLEE, Paul. German, 1879–1940. Born and died in Switzerland

109 *Hannah.* 1910. Wash, pen and ink, 10⅜ x 7⅞″ (27 x 20 cm). Page 46

110 *A Stage for the Use of Young Girls.* 1923. Watercolor, gouache, pen and ink, pencil, 19½ x 12⅝″ (50 x 32.1 cm)

111 *Aged Dwarf.* 1933. Gouache, 13 x 8¼″ (32.8 x 21 cm). Page 74

KLIUN (Ivan Kliunkov). Russian, 1878–1942

112 *Samovar, Pitcher, Decanter, and Glasses.* December 1925. Pencil and colored pencil, 8 x 10¼″ (20.2 x 26.1 cm)

113 *Cup, Pitcher, Bottles.* 1927. Pencil, 12¼ x 7⅜" (31 x 18.5 cm)

KOKOSCHKA, Oskar. British, born Austria 1886. To England 1938; lives in Switzerland

114 *Seated Girl.* (1922.) Watercolor, 27⅜ x 20⅜" (69.5 x 51.6 cm). Page 70

KUHN, Walt. American, 1880–1949

115 *Model with Bare Shoulders.* 1928. Ink wash, brush, pen and ink, 20½ x 16" (52 x 40.6 cm)

KUPKA, Frantisek. Czech, 1871–1957. To France 1895

116 *View from a Carriage Window.* (1901.) Gouache and watercolor with cardboard cutout overlay, 19⅞ x 23⅜" (50.6 x 60 cm). Page 37

117 *Study in Verticals (The Cathedral).* (1912.) Pastel, 16 x 8⅞" (40.6 x 22.5 cm). Page 50

LA FRESNAYE, Roger de. French, 1885–1925

118 *The Sailor.* (c. 1921.) Pencil, pen and ink, 10⅜ x 16⅞" (26.2 x 42.7 cm). Page 66

LAM, Wifredo. Cuban, born 1902. Worked in France, Spain, and Italy from 1923. Lives in France

119 *Untitled.* (1946.) Wash, pen and ink, traces of pencil, 12⅜ x 9½" (31.4 x 24.1 cm). Page 83

120 *Untitled.* (1946.) Wash, pen and ink, traces of pencil, 12⅜ x 9⅝" (31.4 x 24.5 cm). Page 83

LARIONOV, Michael. Russian, 1881–1964. To France 1915

121 *The Buffoon and His Wife.* (1915.) Brush and ink, 13⅛ x 10⅛" (33.3 x 25.5 cm)

LÉGER, Fernand. French, 1881–1955. In U.S.A. 1940–45

122 *Seated Nude.* 1913. Pen and ink, 15⅞ x 22½" (40.3 x 31.6 cm)

123 *A Skater.* 1924. Gouache, brush and ink, pencil, 10⅜ x 8¼" (27.1 x 20.9 cm)

124 *The Eiffel Tower Camouflaged.* (1937.) White gouache on black paper, 12¾ x 9⅞" (32.4 x 25 cm)

LEWIS, Wyndham. British, born U.S.A. 1884–1957

125 *Two Standing Figures.* 1912. Watercolor, wash, pen and ink, 4⅞ x 4¼" (12.2 x 10.8 cm)

LIPCHITZ, Jacques. American, born Lithuania. 1891–1973. In France 1909–41; to U.S.A. 1941

126 *Head.* (1915.) Crayon, pencil, brush and ink, 19⅜ x 12⅜" (49.5 x 32.1 cm)

127 *Seated Nude.* (1915.) Crayon, charcoal, pencil, watercolor, brush and ink, 19⅜ x 12⅞" (49.9 x 32.8 cm). Page 62

128 *Still Life.* (1919.) Charcoal, 15⅜ x 12⅜" (38.9 x 32.1 cm)

López-García, Antonio. Spanish, born 1936

129 *The Staircase.* (1967.) Pencil and wax, 14⅞ x 19½" (37.8 x 49.5 cm). Page 99

Lucebert (Lubertus J. Swaanswijk). Dutch, born 1924

130 *The Centipede.* June 10, 1965. Tempera and torn-and-pasted paper, 19⅝ x 25¾" (49.8 x 65.4 cm)

Marcoussis, Louis. Polish, 1883–1941. To France 1903

131 *Still Life with a Zither, Brandy Bottle, Glass, and Playing Cards.* (1919.) Gouache, brush and ink, pencil, 18¼ x 11⅜" (46.4 x 28.8 cm)

Matisse, Henri. French, 1869–1954

132 *The Necklace.* May 1950. Brush and ink, 20⅞ x 16⅛" (52.8 x 40.7 cm). Cover

Meidner, Ludwig. German, 1884–1966

133 *O Moon Above So Clear!* 1912. Brush and ink, tempera and charcoal, 15¾ x 19¼" (40 x 48.9 cm). Page 48

Metzinger, Jean. French, 1883–1956

134 *The Smoker.* (1914.) Charcoal, 22⅛ x 17¾" (56.1 x 45.2 cm)

Modigliani, Amedeo. Italian, 1884–1920. To France 1906

135 *Woman in Profile.* (1910–11.) Charcoal, 17 x 10⅜" (42.9 x 26.7 cm)

136 *Adam.* (1915–16.) Pencil, 16⅞ x 10¼" (42.8 x 26 cm). Page 60

137 *Harlequinade.* (1915–16.) Pencil, 17⅛ x 10⅜" (43.6 x 26.3 cm). Page 61

Mondrian, Piet. Dutch, 1872–1944. Worked in France 1912–14, 1919–38; in U.S.A. 1940–44

138 *Church Facade.* (1914.) Dated on drawing 1912. Charcoal, 39 x 25" (99 x 63.4 cm). Page 51

Moore, Henry. British, born 1898

139 *Woman Knitting and Girl Reading.* 1947. Watercolor, pen and ink, crayon, pencil, 11½ x 9½" (29.2 x 24.1 cm). Page 85

Nadelman, Elie. American, born Poland. 1882–1946. Worked in France 1904–14. To U.S.A. 1914

140 *Bust of a Woman.* (c. 1913.) Pen and ink, 17⅞ x 14" (45.3 x 35.5 cm)

Nash, John. British, born 1893

141 *The Storm.* (1914.) Crayon, watercolor, pen and ink, 15 x 17¾" (38 x 45 cm)

Orozco, José Clemente. Mexican, 1883–1949. In U.S.A. 1917–18, 1927–34, 1940, 1945–46

142 *Crouching Model.* (1947.) Charcoal, 24⅜ x 18⅞" (62.5 x 47.7 cm). Page 86

143 *Clenched Fist.* (1948.) Crayon and charcoal, 24⅜ x 19" (61.7 x 48.1 cm)

PAOLOZZI, Eduardo. British, born 1924

144 *Dr. Dekker's Entrance Hall.* (1961.) Cut-and-pasted papers on printed illustration, 12⅜ x 9¼" (32 x 23.3 cm)

145 *The Offspring of Eos.* (1961.) Cut-and-pasted papers on printed illustration, 11⅝ x 8¼" (29.5 x 21.1 cm)

PICABIA, Francis. French, 1879-1953. In New York and Barcelona, 1913-17

146 *New York.* (1913.) Gouache, watercolor, and pencil, 22 x 29⅞" (55.8 x 75.9 cm). Page 56

147 *Untitled.* (1919.) Watercolor, brush, pen and ink, 15 x 10" (38 x 25.5 cm)

148 *Untitled.* (1919.) Watercolor, brush, pen and ink, 15 x 10" (38 x 25.5 cm)

PICASSO, Pablo. Spanish, 1881-1973. To France 1904
"Zervos" refers to *Pablo Picasso*, volumes I through XXXI, by Christian Zervos, Editions "Cahiers d'Art," Paris, 1932-76.

149 *Two Nudes.* (Fall 1906.) Charcoal, 24⅜ x 18½" (61.9 x 46.9 cm). Zervos I, 365. Page 40

150 *The Mill at Horta.* (Summer 1909.) Watercolor, 9¾ x 15" (24.8 x 38.2 cm). Zervos II, part 1, 159. Page 41

151 *Burning Logs.* January 4, 1945. Crayon, pen and ink, 19½ x 23½" (49.5 x 59.6 cm). Zervos XIV, 59. Page 81

152 *Figures.* March 9, 14, 15, 1967. Wash, brush, pen and ink, 19⅜ x 25½" (49.2 x 64.8 cm). Zervos XXV, 294. Page 106

153 *The Pool.* January 30, 1968. Pencil, 23 x 30⅝" (58.2 x 77.8 cm). Zervos XXVII, 206. Page 107

POLLOCK, Jackson. American, 1912-1956

154 *Untitled.* (1951.) Brush and black and colored inks, 24¼ x 34" (61.5 x 86.4 cm)

PROCKTOR, Patrick. British, born 1936

155 *Cecil Beaton.* 1967. Watercolor, 11½ x 9" (29 x 22.9 cm)

156 *Tangier.* 1968. Watercolor, 14⅛ x 20" (35.6 x 50.6 cm)

RIVERS, Larry. American, born 1923

157 *Henry Geldzahler.* (1964.) Pencil and cut papers taped to graph paper, 17 x 22" (43.2 x 55.9 cm)

ROTHKO, Mark. American, born Latvia. 1903-1970. To U.S.A. 1913

158 *Archaic Idol.* (1945.) Gouache, wash, brush, pen and ink, 21⅞ x 30" (55.6 x 76.2 cm). Page 80

ROUAULT, Georges. French, 1871-1958

159 *Circus Act.* 1905. Watercolor, pastel, charcoal, brush and ink, 10¼ x 13½" (26 x 34.3 cm)

RUSCHA, Ed. American, born 1937

160 *Wax.* 1967. Gunpowder, 14½ x 23″ (36.8 x 58.4 cm). Page 99

161 *1984.* 1967. Gunpowder, 14½ x 23″ (36.8 x 58.4 cm)

SCHIELE, Egon. Austrian, 1890–1918

162 *Woman Wrapped in a Blanket.* 1911. Watercolor and pencil, 17⅜ x 12¼″ (44.7 x 31.1 cm). Page 47

SCHLEMMER, Oskar. German, 1888–1943

163 *The Figural Cabinet.* (1922.) Watercolor, pencil, pen and ink, 12¼ x 17¾″ (30.9 x 45.1 cm). Page 69

SICKERT, Walter Richard. British, 1860–1942

164 *Pimlico.* 1909. Charcoal, pastel, wash, pen and ink, 21¼ x 19⅜″ (53.8 x 49 cm). Page 42

165 *Jack Ashore.* (1912–13.) Crayon, pen and ink, 14 x 11⅛″ (35.5 x 28.2 cm)

SMITH, Matthew. British, 1879–1959

166 *Seated Woman.* 1915. Watercolor, pen and ink, 11 x 9⅞″ (27.9 x 25.1 cm)

STELLA, Joseph. American, born Italy. 1877–1946. To U.S.A. 1896

167 *Louis Michel Eilshemius.* (c. 1919.) Pencil and crayon, 15 x 12½″ (38.2 x 31.8 cm)

STERNE, Hedda. American, born Rumania 1916. To U.S.A. 1941

168 *Harold Rosenberg.* (1964–65.) Pen and ink, pencil, 11 x 14⅛″ (27.9 x 35.7 cm)

STERNE, Maurice. American, born Latvia. 1877–1957. To U.S.A. 1889

169 *Balinese Woman.* 1913. Charcoal, 22⅜ x 15¼″ (57.6 x 38.8 cm)

STUDNICKI, Juliusz. Polish, born 1906

170 *Chess.* (1963.) Watercolor, gouache, crayon, pencil, 12⅝ x 18¾″ (32 x 47.6 cm)

171 *Hell.* (1965.) Watercolor, gouache, charcoal, 19 x 12¾″ (48 x 32.4 cm)

SZAFRAN, Sam. French, born 1934

172 *Man Asleep.* 1966. Charcoal, 30⅞ x 22¾″ (78.4 x 57.9 cm)

TCHELITCHEW, Pavel. American, born Russia. 1898–1957. Worked in France 1923–38; in U.S.A. 1938–52

173 *Gertrude Stein.* (c. 1927.) Brush and ink, 17⅞ x 11½″ (45.5 x 29.9 cm). Page 72

174 *Edith Sitwell.* (c. 1928.) Gouache, 25¼ x 19¼″ (64 x 48.9 cm). Page 72

VALADON, Suzanne. French, 1867–1938

175 *The Children's Bath.* 1910. Crayon, 12⅞ x 14½″ (32.7 x 36.8 cm). Page 45

WEBER, Max. American, born Russia. 1881–1961. To U.S.A. 1891

176 *Three Bathers.* 1909. Gouache, 7⅜ x 9″ (18.6 x 22.7 cm)

177 *Seated Nude.* (1911.) Pen and ink, traces of pencil, 12¾ x 9½" (32.4 x 24.1 cm)

WHITELEY, Brett. Australian, born 1939. To Great Britain 1961

178 *Deya, Mallorca Day.* (1967.) Brush and pen and ink, paper cutout, pencil, 22 x 30" (55.9 x 76.2 cm)

WILLIAMS, Fred. Australian, born 1927

179 *Desert Dust Storm, Tibooburra.* 1967 (verso). Gouache and synthetic polymer, 22½ x 30" (57.1 x 76 cm). Page 104

180 *Flinders Island.* 1968 (verso). Gouache and synthetic polymer, 22⅜ x 30¼" (56.8 x 76.8 cm). Page 105

Certain drawings listed in the catalog are lent to the Joan and Lester Avnet Collection by their present owners. The Museum wishes to thank these lenders, who have agreed that their drawings may be included. The drawings are catalog numbers 3, 9, 10, 15, 18, 30, 31, 33, 90, 91, 121, 141, 149, 157, 166, 174, 179, 180.

PHOTOGRAPHY CREDITS

David Allison: 74, 104, 105; Kate Keller:* *Frontispiece*, 41, 44, 48, 51, 52, 54, 58, 60, 64, 67, 68, 72, 76, 81, 83 *left and right;* James Mathews: *Cover*, 39, 40, 43, 46, 47, 50, 59, 62, 63, 66, 70, 71, 75, 77, 79, 84, 85, 98, 99, 100 *left and right*, 101, 102 *left and right*, 103; Mali Olatunji:* 42, 45, 53, 54, 57, 61, 69, 73, 78 *left and right*, 80, 86, 87, 95, 96, 97; Rolf Petersen: 88 *left and right,* 89, 90, 91, 92, 93; Charles Uht: 37, 38, 55, 56, 65, 82, 94, 99, 106, 107; Malcolm Varon: 49

**Currently staff photographer of The Museum of Modern Art*